THE ARTS DIVIDEND

REVISITED

WHY INVESTMENT IN CULTURE PAYS

DARREN HENLEY

Elliott&Thompson

First published 2016 by
Elliott and Thompson Limited
2 John Street
London WC1N 2ES
www.eandtbooks.com

This revised and updated edition first published in 2020

ISBN: 978-1-78396-518-2

Poem on page 40: From *Search Party* by George the Poet, published by Virgin Books. Reproduced by permission of The Random House Group Ltd.

All author royalties earned from the sale of this book will be donated to the First Generation scholarship fund at Manchester Metropolitan University. The scheme supports young people from backgrounds who do not usually enter higher education, enabling them to access university, and to succeed once they are there. For more information: https://www2.mmu.ac.uk/giving/firstgeneration/

9 8 7 6 5 4 3 2 1

A catalogue record for this book is available from the British Library.

Typesetting: Marie Doherty
Printed in England by TJ International Ltd

contents

first word . . .

The year 2020 will forever be known as the time when the Covid-19 pandemic swept around the globe. It changed how we experienced life: what we thought, what we did, the way we communicated, how we were creative.

We're still a long way from understanding the extent of the virus's impact, but there's no question that its toll on our lives and on our communities will be far-reaching. The health of friends, relatives and colleagues has been at the forefront of all of our minds – and, quite rightly, the selflessness, skill and dedication of the nurses, doctors, carers and support staff working across the NHS and the care sector has been applauded. But while the impact of Covid-19 has been felt most quickly and keenly in the areas of health and health-care, in the end, it seems, few aspects of our lives will remain untouched. From this point on, for many people and in many places, much will never be the same.

The Arts Dividend Revisited charts the five-year period before the onset of Covid-19, and given the seismic events that have played out since then, some might ask whether this book's conclusions remain relevant. But despite the enormous challenges that have arisen in the wake of the pandemic, the

central arguments in these pages are as urgent and relevant in the world we find ourselves today – and for the future world we would like to build – as they have ever been. Public investment in creativity and culture means that our artists, arts organisations, museums and libraries have the power to change lives for the better in communities across England. And I believe that the need for this investment in our society has never been greater.

The lockdown and a sustained period of enforced social isolation gave us a momentary taste of a world in which we were prevented from coming together in theatres, concert halls, arts centres, studios, galleries, bookshops, village halls, museums or libraries; a world where we couldn't take part in carnivals and festivals; a world with tough restrictions on how audiences and communities could experience the work of artists, makers, curators, librarians, performers and educators. But the restrictions also showed us the significance of our humanity and of our social interaction – and the extent to which we had previously taken these for granted.

In a dramatically changed environment, I was struck by the way in which so many people across the country, young and old, exhibited their own personal creativity, by making, singing, dancing, playing and doing. I was also struck by the number of cultural organisations that speedily redefined the roles they play in their local communities. They exhibited imagination, flexibility, compassion and kindness. They lived by their values and, in so doing, they illustrated their value.

As the Chancellor of the Exchequer, Rishi Sunak, noted in one of his speeches at the start of the pandemic:

> *'Now, more than any time in our recent history, we will be judged by our capacity for compassion. Our ability to come through this won't just be down to what government or business can do, but by the individual acts of kindness we show one another. When this is over, and it will be over, we want to look back at this moment and remember the many small acts of kindness done by us and to us. We want to look back at this time and remember how we thought first of others and acted with decency.'*[1]

With adversity, also comes creativity. The Olivier Award-winning musical *Come From Away* is a life-affirming story of the 7,000 passengers from all over the world who were grounded in Canada during the wake of 9/11, and the small Newfoundland community that invited them into their lives. I saw it at London's Phoenix Theatre at the beginning of 2019 and it quickly became one of my favourite new musicals, deserving all of its many plaudits, not only in the West End, but also on Broadway. It is work of creative genius, with a joyous and happy ending, born from a moment of international crisis.

Covid-19 has delivered another international crisis. Its ending is not yet clear. In a society where we've increasingly placed

[1] https://www.gov.uk/government/speeches/the-chancellor-rishi-sunak-provides-an-updated-statement-on-coronavirus

emphasis on certainty and control in our lives, the pandemic turned normality on its head. We were forced to realise that we're not always the writers of our own scripts or the directors of our own stories. And that can be tough to deal with. But if I am certain of one thing, it's that the people and organisations who together have made England such a big cultural and creative player on the world stage will bounce back stronger than ever.

I'm privileged to have witnessed the work of our most imaginative and innovative people and organisations over the past five years – many of them mentioned on these pages – and that gives me a huge amount of optimism for our future. I'm not saying it's always going to be easy, but new sparks of creative genius have already emerged. And public investment in artists, arts organisations, museums and libraries will nurture those creative sparks, helping them to grow, and to light up our lives for many years to come.

about this book

This book contains my personal reflections on England's arts and cultural landscape in 2020, five years on from my appointment as chief executive of Arts Council England.

I wrote the first edition of *The Arts Dividend* back in 2016, some twelve months after I had taken up the job. At that point, few people could have predicted the scale of political change that has since unfolded in the UK.

Now, at the start of a new decade, as the UK redefines itself on the international stage as a country outside of the European Union, the time feels right to update this book. In this fully revised edition, my central argument remains the same, but since the publication of *The Arts Dividend*, I have become steadily more passionate about the ways in which public investment can help people to lead happier, healthier, more fulfilling lives. In my travels around the country, and my conversations with artists, cultural leaders and members of the public, I've gained new experiences and insights, and learned much, much more about the good that creativity and culture can do across England. And I wanted to gather together that learning and share it here.

I have also been on a more formal learning journey in the intervening period. My thinking has been greatly informed by studying for a professional doctorate at Middlesex University exploring the role of the outsider as an agent for change. This has led to further postgraduate study of coaching and behavioural change at Henley Business School and of applied positive psychology – the science of what makes life worth living – at Bucks New University. I'm still on that learning journey. To be honest, I hope that it turns out to be a voyage of discovery that never ends. Already it's helping to shape my thinking and understanding of the world in which we now find ourselves. It's also casting new light for me on how those of us who work in the creative industries can help make even more of a positive difference to the world around us.

This is not an official Arts Council publication; these are my personal opinions. They have been shaped by my experiences and by the people I have met during my first five years at the Arts Council. And while I am writing about the effect of artists, arts organisations, museums and libraries generally, I have seen the impact of the investment that Arts Council England makes, and it is inevitable that what I cover should reflect that insight.

Although I can in no way claim to write with anything approaching the same supreme elegance, style or enduring impact, I like to think that this book follows in the tradition of J. B. Priestley's 1934 classic *English Journey*. Like Priestley, I hope to shine a spotlight on parts of England, their artists, their arts organisations, their museums and their libraries

that have not always enjoyed the nationwide attention that they deserve – nor the benefits that it can bring.

Unlike Priestley, I cannot lay claim to the best subtitle of any work in this genre: 'Being a rambling but truthful account of what one man saw and heard and felt and thought during a journey through England during the autumn of the year 1933.' But this too is a book rooted in the reality of what I have witnessed on a non-stop journey through villages, towns and cities right across England. It is, I suppose, my own rambling but truthful account of what I saw and heard and felt and thought as I journeyed through England's arts and culture scene some eighty-five years later. At the beginning of the first edition of this book, I offered an explanation of why I had chosen to write down my experiences and the perspective they had informed at that moment, one year after joining the Arts Council. It was in case there should ever come a time (simply because it had all become much more familiar) when our national art and culture might seem less remarkable to me than it really is. I am happy to say that four years later, familiarity has not bred complacency. Quite the opposite: I remain just as excited about our country's artistic individuals and cultural organisations as I did back then.

I am just as optimistic too, because this is also a book about the future; about risk, innovation and imagination. It is as much about who and how we might be tomorrow as it is about today. And it is about the way in which sustained, strategic public investment in creative individuals and cultural organisations can help us all to lead happier lives.

In England, we are blessed with unique creativity. It's too easy to take it for granted. We should remember everything that it does for us; nurture it; savour it; talk about it. If it flourishes, then so do we all.

introduction

This book argues that public funding for art and culture is critically important because a sustained, strategic approach to cultural investment pays big dividends in all of our lives.

I understand that words such as 'investment' and 'dividends' might be dismissed as economic rather than creative terms. Where's the art in all this? The point I'll make is that these dividends flow only when the art excels. Quality and ambition sit at the heart of *Let's Create*,[1] the Arts Council's ten-year strategy for creativity and culture in England from 2020 to 2030, and they are at the heart too of the examples I will share throughout this book of artistic and curatorial excellence. While there will always be healthy debate about what quality means within the artistic community, the public tend to know straightaway when they are being fobbed off with something less than the real deal. To my mind, if you want truly popular, memorable and resonant art, it has to be the best.

Before I joined the Arts Council, I spent fifteen years leading the UK's biggest classical music radio station, Classic FM,

1 https://www.artscouncil.org.uk/letscreate

❝ *Great art changes people's lives. Artists must be able to challenge preconceptions, to think differently and freely, and to create great art in new ways.* **❞**

bringing some of the greatest works of art to a mass-market audience, so I have never understood the distinction some make between 'great' and 'popular'. There are works of art that are ahead of their time, but few artists have ever striven not to be read, or to have their work leave people untouched. The greatest art is the most human. Given time it will always find its audience.

That doesn't mean that all art will be equally popular in every public constituency. Taste, custom and history have to be taken into account – elements intrinsic to the richness of our national culture – and these are every bit as influential as the aesthetic traditions of an art form. Kwame Kwei-Armah, the artistic director of London's Young Vic, says that theatre, for example, is a 'catalyst for debate about the big themes' in society. And I reckon he's right.

Artists must be able to challenge preconceptions, to think differently and freely, to imagine new possibilities, and to create great art in new ways. Imagination in particular is vital to creativity: if we can draw on our experiences to call up an image of the world in our consciousness, we can create an environment ripe for experimentation. For me, the words of the poet Lemn Sissay capture this beautifully:

'We turn to art and creativity because it is the greatest and truest expression of humanity available to all. And all things are possible in the eye of the creative mind. To be more is first to imagine more.' [2]

It's only by encouraging the diversity of individual artistic perspectives that you can ensure that you are reflecting the lives, loves and interests of audiences – that everyone is getting the best. From a funding perspective, what matters is that you support talent and champion ambition, imagination, innovation and risk. These are integral to creativity. We don't want to dilute these values.

Great art changes people's lives. I'd like all our museums, our libraries, our artists and our arts venues to be genuinely popular, to be a part of the lives of all their communities, so that everyone in England can enjoy the Arts Dividend and have their lives enhanced, no matter who they are, or where they live.

Over the past five years, I've travelled the length and breadth of England, coming to know and understand how our creative ecology works, and I believe we're on the way to realising a vision in which everyone everywhere can have equal access to the best culture we can make close to where they live. But while we are moving forwards and have identified our desired destination, there remains a considerable distance to go. It is

2 Speech by Lemn Sissay at Creative England's Be More Manchester Conference, 18 February 2018

this challenge that *Let's Create*,[3] Arts Council England's strategy for 2020 to 2030, aims to tackle and I will be reflecting on how we plan to do so in these pages.

Across England I've visited exciting new venues, many of which have been transformed through major capital investments made by Arts Council England using taxpayers' and National Lottery funds: Storyhouse – the new library, theatre and cinema in Chester; The Word – a brand new national centre for the written word in the heart of South Shields; The Box – the new gallery, archive and museum in Plymouth; Leeds Playhouse; the John Hansard Gallery in Southampton; and Hallé St Peter's – a new home for the Hallé Orchestra in the heart of Manchester's burgeoning Ancoats district.

I've seen work of ambition and innovation: from the modern art exhibitions at Nottingham Contemporary to the technology embraced by the creative community at Pervasive Media Studio at Watershed in Bristol; from the work created by local young people at the Studio 3 Arts Centre in Barking to the terrific writing, acting and production values of *The Tao of Glass* produced by Improbable, Manchester International Festival and Manchester's Royal Exchange Theatre.

Everywhere you go in England, you'll find brilliant art breaking out in unexpected places: an opera about football in Sunderland Minster; a contemporary dance performance as part of the Dance Umbrella festival on top of an NCP car

3 https://www.artscouncil.org.uk/letscreate

park in Farringdon; or the Birmingham Opera Company performing Shostakovich's epic *Lady Macbeth of Mtsensk* with the City of Birmingham Symphony Orchestra in a disused nightclub by Edgbaston Reservoir.

All this sits alongside the consistent celebration of all that is best about our national culture, whether it's a concert by the Black Dyke Band at the Sage Gateshead, the opening night of the London Jazz Festival at the Barbican Centre, the celebration of Diwali at the BAPS Shri Swaminarayan Mandir in Neasden (more popularly known as the Neasden Hindu Temple), or a brilliantly curated exhibition of the work of eighteenth-century artist George Stubbs at Milton Keynes Gallery.

These are just a few of the many events and places that I have experienced for myself since I've been at the Arts Council – and I am only able to take in a fraction of what is on offer, every day. Put together, they make up a wonderfully interconnected cultural ecology that extends across our villages, towns and cities. And, separately, each of them also shows the value of public investment in arts and culture.

Seventy-five years of public investment

In 2021, the Arts Council will mark the seventy-fifth anniversary of the granting of its first Royal Charter. The Arts Council grew out of the Council for the Encouragement of Music and the Arts (CEMA), which was set up in 1940 with the aim of supporting Britain's culture as part of the

war effort. The driving force behind the creation of the Arts Council, and its first chairman, was the economist John Maynard Keynes.

It is salutary to note that it was an economist, rather than an artist, whom generations of creative minds since the Second World War have to thank for the body that provides public investment in their work. Keynes was a passionate believer in the arts. He collected paintings and regularly attended the opera, ballet and theatre. More than half a century ago, he recognised the value that arts and culture bring to our lives.

In a BBC Radio talk in 1945 to announce the Arts Council's establishment, Keynes underlined the importance of creative freedom for the artist:

> '. . . who walks where the breath of the spirit blows him. He cannot be told his direction; he does not know it himself. But he leads the rest of us into fresh pastures and teaches us to love and enjoy what we often begin by rejecting, enlarging our sensibility and purifying our instincts.' [4]

Keynes was the architect of the Arts Council's Royal Charter, although he died shortly before it was ratified. The Arts Council was funded with a grant from the Treasury, operating at arm's length from the government. The principle is still upheld today. In addition to government funding (known

[4] Keynes, John Maynard, 'The newly established Arts Council of Great Britain (formerly CEMA). Its policy and its hopes: a talk by Lord Keynes', BBC Home Service (8 July 1945)

as 'grant in aid'), since 1994, the Arts Council has also distributed National Lottery Good Causes funding to arts and culture activities across England.

In his first speech in the job in 2017, seven decades on from Keynes's radio talk, the current chair of Arts Council England (and one of Keynes's successors), Sir Nicholas Serota, argued that culture and creativity should be on offer to everyone in twenty-first-century England:

> *'An encounter with art and culture can be a catalyst for change in all our lives. I believe that it is through having, and sharing these experiences that we become stronger, as individuals and as communities, and become a fairer nation. Public investment in our arts, our museums and our libraries is investment in a shared cultural language, with many different voices and accents. I want that language to be available to everyone.'*[5]

Things have changed since the days of Keynes. Back in the 1940s, there could sometimes appear to be a lofty separation between artists and the rest of the population, and politicians and funding organisations took a rather patrician view of audiences, who were offered what the establishment thought was good for them, rather than what they might actually want. Those who were 'in the club' were allowed to enjoy the best of art and culture. The rest were likely to be given a watered-down substitute – or nothing at all.

[5] https://www.artscouncil.org.uk/sites/default/files/download-file/Sir_Nicholas_Serota_No_Boundaries_speech_280317.pdf

In the past, the art that was widely considered to be great was largely kept away from the population, as if locked up in a cupboard, too remote or expensive or exclusive to be accessed. In the twenty-first century we are blowing the doors off that cupboard. The riches are available for everybody to enjoy and the Arts Council puts the needs of the public at the centre of its thinking. Art, culture and creativity are no longer a luxury, remote from everyday life; rather they are an essential part of it.

From 'making the case' to 'making a difference'

If you've read this far, you are more than likely interested in this subject already. Perhaps you work in an arts organisation, a museum, a gallery or a library. Maybe you are a teacher or a lecturer educating the generation who will create the great art of the future. You might be involved in political decision-making around the arts at a local or national level or have a career as a painter, a photographer or a sculptor, a dancer, a musician or an actor. You might be a film-maker, a curator, a librarian or an archivist; a poet, a playwright or a novelist. Perhaps you use traditional crafts to create your art – or the latest digital technology. Or you could be part of my favourite group of all: an audience member, a reader, a viewer or a listener – somebody who pays their taxes and plays the National Lottery and so has a personal stake as an investor in our national cultural infrastructure.

Whatever your connection with the arts, I hope that you agree with Keynes and Serota on the importance of public

investment in arts and culture. Perhaps this book will help articulate that belief. But I hope too that it will be a useful read for those who are not directly part of this cultural world and who, perhaps, are yet to be convinced of the significance of art and culture – and why it's so important that we continue to invest in these areas of our lives.

Those of us who work closely with libraries, museums, arts organisations and individual artists see the benefits day in and day out. It's our responsibility to make the case for the value of the arts – and for public investment – to the widest possible audience. And we need to get that argument across in ways that make sense.

We can do this most powerfully by showing how public investment in artists, arts organisations, museums and libraries makes a huge difference, not only to the major cities that are most often talked about, but to every part of the country – to the communal lives of our villages, towns and cities everywhere.

Thinking how we can encourage culture and creativity in less obvious places is a preoccupation of mine, and I am always excited when I visit towns that might not be regarded as conventional tourist hotspots – and discover great cultural riches.

So I was thrilled to walk around a corner in the Huddersfield Art Gallery to see a Henry Moore sculpture, slap bang next to paintings by L. S. Lowry and Francis Bacon. And when I visited the Royal Albert Memorial Museum in Exeter and the

Harris Museum in Preston, I was delighted by the breadth of the artistic riches on show and the obvious pride that people who live there have in the museums and collections.

One of the most striking elements of the English cultural landscape is the abundance of amazing festivals. Back in Huddersfield again, I caught the first concert of its contemporary music festival. I travelled further north for the dramatic opening night of Stockton International Riverside Festival, east for the launch of the Norfolk and Norwich Festival, west for the Cheltenham Jazz Festival and south for the beginning of the Brighton Festival. Each of them provided really excellent art to hungry audiences.

Big cities like Manchester, Newcastle, Liverpool, Leeds, Birmingham and London are surrounded by large population centres that might not be so well known but still have great civic pride. The people who live, work and study in these smaller towns deserve to reap the benefits of creativity and culture in their areas too. In the past, many of them have been overlooked, but I am a big believer that the time has now come to redress that balance and to do so in a sustained and strategic way, making investments that deliver long-term change in our towns, many of which have a proud heritage of innovation and creativity that is crying out to be rekindled. There is still a great deal of inequality to overcome, but during my travels around the country, I have seen how artists, arts organisations, museums and libraries can play their part in reigniting the spark of creativity in communities across England, helping to reimagine and

regenerate places. So, it's been exciting to walk the streets of Barking, Barnsley, Barrow-in-Furness, Blackburn, Bradford, Bridgwater, Coventry, Croydon, Darlington, Middlesbrough, St Helens, Stoke-on-Trent, Wakefield, Walsall, Wigan and Wolverhampton, and to learn first-hand how they all share a genuine ambition that art and culture should be a part of local life.

You can find the same inspirational message in the towns that dot our coastline, whether it's Bournemouth or Hastings, Blyth or Scarborough, Great Yarmouth or Grimsby, Ventnor or Watchet. And it's important to remember the role that artists, arts organisations, museums and libraries can play in counties with big rural areas such as Northumberland, Lincolnshire, Cumbria, Cornwall, Herefordshire and Dorset. The population in these parts of England may be dispersed, but the people who live there have just as much right as those who live in big cities to benefit from the opportunities that individual creativity and high-quality culture bring.

When I joined the Arts Council in 2015, I vowed to make sure that my life didn't consist solely of sitting behind a desk in London. Instead, I set out to spend around half my working time in villages, towns and cities across the country. Five years later, I've kept my promise, visiting all the places I've just listed, and many more besides. After eighteen months in the job, I stopped counting the places that I'd been to. By then, my tally had reached 157 different villages, towns and cities across England. In fact, I suspect that I've seen more artistic performances and exhibitions, visited

more cultural organisations, and met more community artists and arts groups on their home turf than anyone else in England during the past five years. But, doing the job that I do, that's exactly as it should be – and I wouldn't have it any other way.

Although I've now stopped keeping count of all the places involved, I haven't stopped travelling, observing and learning. And I don't intend to anytime soon. During my non-stop journey, I've seen and heard the evidence for myself of the benefits of creativity and culture in people's lives. Over the coming pages, alongside anecdotal observations from my travels, I will reference some of the mass of research showing the value of investment in art and culture. But I should stress that this book has no academic pretensions. It remains for the general reader, whether they work in the arts or not. I hope that I can help you share my excitement about the immense value of the arts, museums, libraries and creativity in our lives.

If you see this value, I hope you'll join us to make the case for public investment. And once that case has been made, those of us who work in the arts or in museums or libraries have to follow through and prove it in practice, ensuring that our artistic and cultural riches are shared with all parts of society.

Making this happen requires foresight, sensitivity to the needs of communities and an understanding of how talent develops. If we plant and protect the acorns of artistic ambition, these will in time grow into magnificent oaks. It takes

patience, care and sustained investment. But everywhere I've gone, I've seen that public investment is paying dividends – and those dividends will only grow in the years to come. It will not surprise you to learn that I strongly believe that more public investment in artists, arts organisations, museums and libraries will yield greater benefits, more quickly, for more people, in more places. There are so many life-changing creative opportunities just waiting to be unleashed.

It's not subsidy

Art and culture in Britain is funded by a network of public and private investment, including local authorities, central government, the National Lottery, higher education institutions, philanthropists, business sponsors, charitable foundations and the ticket-, book- or artwork-purchasing public. It's a structure that has evolved over a long period of time, and everyone participates because it works for them, one way or another. In fact, it has helped shape the variety that's a characteristic of our national culture.

But let me be clear: these funders do not 'subsidise' the arts. It's never a one-sided transaction in which one party gives for no return; there is always a return, though it may not be immediately obvious or even accrue to the original benefactor, and they may not expect it to. The return may be in terms of the artistic experience, or the support of creativity and talent. Or there may be a clear economic payback, the promotion of a company's commercial interests, or an interest in supporting the life of a community.

But there's no subsidy. Personally, I cannot abide the term. The Arts Council doesn't use public money to subsidise art and culture – it invests public money for the benefit of all the public. I'll be showing how that works. And I guarantee that in the rest of the book, you won't see the word 'subsidy' again.

The political argument

In 1964, Harold Wilson appointed Jennie Lee to the role of the UK's first arts minister. She built on the work of Keynes, penning a visionary White Paper in 1965 entitled 'A Policy for the Arts: The First Steps'. This contained an unequivocal recognition of the value of art and culture:

> *'In any civilised community the arts and associated amenities, serious or comic, light or demanding, must occupy a central place. Their enjoyment should not be regarded as something remote from everyday life.'* [6]

Let's travel forward into our century, and a speech by Prime Minister Boris Johnson at Manchester Science and Industry Museum just three days after he had moved into 10 Downing Street in July 2019. It was the first speech he had made outside London since taking on the top job – and to me, it seemed significant that he had chosen to make it in a cultural institution. Standing at the podium, he listed investment in

[6] Lee, Jennie, 'A Policy for the Arts: The First Steps', Her Majesty's Stationery Office (February 1965)

culture as being key to shaping great towns and cities across the country:

> *'People love Manchester because of the fantastic arts and enter-tainment here, the football and music, the heritage and the creative industries that make it such a lively, wonderful place to live and work. We need to help places everywhere to strengthen their cultural and creative infrastructure, the gathering places that give a community its life.'* [7]

The Prime Minister also recognised the way in which invest-ment in cultural institutions can improve the lives of the people who live in post-industrial towns, promising new investment:

> *'They'll also get help with that vital social and cultural infra-structure, from libraries and art centres to parks and youth services: the institutions that bring communities together, and give places new energy and new life.'* [8]

Art is often, quite rightly, political. Long before a formal arts funding structure was put in place at the end of the Second World War, artists used their art to espouse viewpoints con-trary to those of the government of the day. The creative freedom of artists is of paramount importance. It's one of the reasons it's so important for the Arts Council to operate at arm's length from the government.

[7] https://www.gov.uk/government/speeches/pm-speech-at-manchester-science-and-industry-museum

[8] Ibid.

Keynes was a Liberal, Lee was Labour, and Johnson is a Conservative. Like most politicians (or artists, for that matter), they might not agree on what constitutes great art and culture, nor on what the role of art and culture should be in society, but over the years there has been a surprising degree of political consensus about its fundamental value.

Nonetheless, when budgets have come under pressure at a national and local level, there has been a tendency for the arts, museums and libraries to be viewed as 'nice to have', rather than a necessity. I hope that this perception is changing. Certainly, Boris Johnson's speech in Manchester did not portray them as an optional luxury but as an essential part of life in thriving communities – and significant catalysts for positive change and growth.

In this book, I argue that any reductions in investment will undermine this essential work in places where it is most needed. This is important both at national and local funding levels. Local authorities have a crucial role to play in building and supporting the cultural ecology and physical infrastructure. They are the Arts Council's major funding partners, and the withdrawal of their support leaves a hole in funding that cannot be filled.

❝ *The creative freedom of artists is of paramount importance. It's one of the reasons it's so important for the Arts Council to operate at arm's length from the government.* **❞**

Even at times when funding is tight – and it has been tight for councils across England since the global financial crisis of 2008 ushered in more than a decade of austerity – the most effective local authority leaders and chief executives are working alongside the Arts Council and other national funding bodies to ensure that arts and culture continue to be a part of their core strategy, bringing creative energy and vigour to their communities. It's what makes them great places to live, work and do business.

Ideally, I'd like to see an even closer relationship between national and local government and the practitioners of arts and culture. I believe that artists, arts organisations, museums, libraries and our commercial creative industries should have a valued place in the process of policy and decision-making in Whitehall – and in town halls, city halls and county halls.

Investing in the next generation

The UK's status as a creative nation is sometimes better recognised abroad than at home, though in recent years there has been a greater understanding of the economic value of the creative industries to 'UK plc'. Our future success depends upon a sustained supply of national talent. We need to identify, nurture and develop this talent from an early age.

So, providing children and young people with the highest quality cultural education is vitally important. Every child should be able to enjoy great art and culture for its own sake.

School subjects such as art and design, dance, drama and music should not be seen as entertaining optional extras. They give young people knowledge and skills that will help them build careers that are creatively and economically valuable.

Some will go on to study at our excellent network of conservatoires or specialist arts universities and will work in the cultural sector or creative industries. Others will study a broad range of subjects in further or higher education institutions – but they will do so as more rounded and confident human beings, trained to think creatively, because art and culture has been a strong part of their education.

Outside the classroom, children and young people should have the opportunity for their lives to be enriched by the performing arts, by museums, galleries and libraries. They should take part in creating new art and culture, and they should be encouraged to experience the very best that is on offer. These opportunities should be the same for all children, no matter where they begin in life. Every child should have the chance to realise their talent, whoever they are and wherever they live. They should not be disadvantaged by the colour of their skin, their religion, their family background, gender, sexuality, disabilities, geographical location or lack of money. During her husband's time at the White House, the USA's former first lady, Michelle Obama, made it one of her priorities to improve cultural education for those from poorer socio-economic backgrounds:

'Arts education is not a luxury, it's a necessity. It's really the air many of these kids breathe. It's how we get kids excited about getting up and going to school in the morning. It's how we get them to take ownership of their future.' [9]

We need talent, of every sort. And to get it, we will have to break down the barriers that block young creative people from flourishing and build bridges that allow that talent to proceed and succeed.

I will talk about this in detail in Chapters 1 and 2, because it is so important. The development of the next generation of creative talent should be a priority for those who care about the future of art and culture in this country.

Art is valuable in itself

It's important to underline that there are a multitude of intrinsic benefits that come from being surrounded by quality artistic and cultural events and experiences – and from simply being involved in the process of creating something. Paintings, sculptures, photographs, dance, drama, music, literature, films, poetry, carnivals, parades, crafts, digitally created art – all of these bring profound pleasure on an individual and collective level.

[9] https://obamawhitehouse.archives.gov/the-press-office/2015/11/17/remarks -first-lady-national-arts-and-humanities-youth-program-awards

ff *We must always celebrate the intrinsic value of art as a human, emotional, transformative experience.* **JJ**

Great art can transport us to a different place. It can take us from the mundane realities of life to a new world. It can fire our imagination and show us the possibilities of other lives, other places – even other galaxies. It can lead us to question ideas and it can challenge our assumptions.

For me, more than anything, the best art is always provocative. It always gets my attention – and a suitable reaction: I love it; I dislike it; it perplexes me; or it shocks me. It stimulates an emotional response.

This book talks about the Arts Dividend – the great benefits art and culture confer on our society. But art that is not engaging or pleasurable or cannot be enjoyed for its own sake, is scarcely likely to have much of an impact in other ways. So we must always celebrate the intrinsic value of art as a human, emotional, transformative experience. That experience in itself is a reason for investing in art and culture. But it's not the only reason.

Artistic and cultural activities can produce a wide variety of outcomes, beyond purely having an intrinsic value. This adds to the excitement and relevance of the art. For some great artists, it's an inspiration. As the sculptor Sir Antony Gormley (creator of the *Angel of the North*) put it:

'Maybe this is a utopian view of art but I do believe that art can function as a vehicle, that it isn't just a cultural pursuit, something that happens in art galleries. Unless art is linked to experience and the fear and joy of that, it becomes mere icing on the cake.'

If you like, art can be used as a tool to secure a beneficial outcome – it is 'instrumental'. For me, there doesn't have to be a choice between instrumental and intrinsic benefits. I'd maintain that the best of art has the greatest value in every way. But it's important that we never think of investment in arts and culture solely as a tool. We should not invest in artists and cultural organisations only for instrumentalist purposes. Invest in quality and creative ambition and the other benefits will follow.

Arts Council England's strategy *Let's Create* neatly encapsulates the organisation's vision for the next decade:

'By 2030, we want England to be a country in which the creativity of each of us is valued and given the chance to flourish, and where every one of us has access to a remarkable range of high-quality cultural experiences.'[10]

Different people will define outcomes in different ways, but for me, there are seven 'dividends' that flow from sustained investment in art and culture. In the seven chapters that follow, I'll look at each of them in turn.

10 https://www.artscouncil.org.uk/letscreate

And one last thing. . .

Creative endeavours – whether as a participant or as a member of an audience – are more often than not fun. So, although there are lots of extremely worthwhile reasons for investing in the arts, museums and libraries which I will set out in full over the next seven chapters, there's no denying that they can be immensely enjoyable. They make our lives happier. And that's no trivial thing. There's a playfulness that's so essential to creative discovery.

Participating in the arts, or visiting a museum or a library, is a way to reawaken the invention, imagination and immediacy we all have inside us. It's a way not only to have fun – but to reap the benefits of that fun too. As the novelist Ben Okri puts it so wonderfully:

> 'Creativity, it would appear, should be approached in the spirit of play, of foreplay, of dalliance, doodling and messing around – and then, bit by bit, you get deeper into the matter. . . Do not disdain the idle, strange, ordinary, nonsensical, or shocking thoughts which the mind throws up. Hold them. Look at them. Play with them.'[11]

11 Okri, Ben, *A Way of Being Free* (London: Head of Zeus, 1997)

the creativity dividend

in brief . . .

Creativity is at the heart of great art and culture, and it runs through all six of the other Arts Dividends covered in later chapters. Creativity changes a place and the people who live there for the better. When people are creative, they are more inventive, imaginative and innovative. They think freely and see and do things in new ways that remake the world around them. But to be a truly creative nation, we need to identify and nurture talented people from all parts of the community. Without a genuinely diverse talent base, creative possibilities will be capped and personal potential will remain unfulfilled.

The recipe for creativity

Creative people eat a lot of cake. And they bake a lot of cakes too. In my experience they cook almost everything with great aplomb. Having spent so much time in the company of the widest imaginable range of artists and creators over the past five years, I can assert this with absolute confidence. My growing waistline is testament to the delicious homemade treats I have been served by the people I've met at arts venues up and down the country. I suppose it's obvious really. Creative people like creating things, so why should great food be an exception?

I believe that there is creativity embedded in all of us and that we could all be artists if we either wanted to apply that creativity, or if we knew how to do it. The broadcaster Andrew Marr summed up the creative disposition of human beings neatly in an article for the *New Statesman*:

> *'It's making. We are the making animal. Unless we make – that is, in some small way, change the world around us – we are not fully human. The making can be a book, a garden, cooked food, but the best making is the making of other human beings, kind and competent, through parenting, biological or otherwise. But what we do is, we change the world around us. We are because we make.'*[1]

[1] https://www.newstatesman.com/culture/2015/01/andrew-marr-it-urge-create-makes-us-human

One of the meals I've enjoyed most during my time at the Arts Council was eaten while sitting with a group of actors outside a National Trust barn on the cliffs near Mevagissey one hot summer's evening. This is the home of Kneehigh, a remarkable theatre company that creates all of its new work in Cornwall, but has a reputation for innovation that has seen its productions grace stages not only all over the UK but also around the globe. I was privileged to be allowed to sit in on their rehearsals for *946: The Amazing Story of Adolphus Tips*, an adaptation of a Michael Morpurgo book about the D-Day landings. It was to be premiered at 'The Asylum', Kneehigh's huge tent, pitched in a field at the wonderfully named Lost Gardens of Heligan just down the road from their rehearsal barns.

Besides what we might think of as conventional acting, Kneehigh is famous for using music and puppetry to tell its stories, and it was fascinating to be given an insight into their production process. I was struck by the camaraderie and warmth: everyone looked as though they were enjoying themselves – although they were in fact working incredibly hard. It was fun for me to watch, but there was deadly intent in the relentless rehearsing of lines, actions, songs and dances, all followed by feedback from the director Emma Rice (who, along with Michael Morpurgo, had also adapted the book for the stage).

This creative process, involving constant repetition with incremental minute improvements, is as much a part of science as it is of art. It's a technique embraced by great

designers, such as Sir James Dyson, the inventor of the dual-cyclone vacuum cleaner. When they're working in inventing mode, engineers like Dyson don't expect to get everything right first time; but they know that the goal is worth pursuing, and so they try and try again, gradually moving as close to creative perfection as they can. In his book *Black Box Thinking: The Surprising Truth About Success*, Matthew Syed discusses the ways in which initial failures in the creative process drive innovation. James Dyson shared his insights:

> *'People think of creativity as a mystical process. The idea is that creative insights emerge from the ether, through pure contemplation. This model conceives of innovation as something that happens to people, normally geniuses. But this could not be more wrong. Creativity is something that has to be worked at, and it has specific characteristics. Unless we understand how it happens, we will not improve our creativity, as a society or as a world.'* [2]

And it's not just business gurus like James Dyson who think this way. Grayson Perry, member of the Royal Academy and winner of the Turner Prize, is quick to rubbish the idea that success as an artist is some kind of easy ride:

> *'There is a lingering myth that artistic success is God-given and that all the artist need do is lounge around drinking absinthe*

2 Syed, Matthew, *Black Box Thinking: The Surprising Truth About Success* (London: John Murray, 2015)

and then, occasionally, in a fit of impassioned inspiration, knock out a masterpiece in a furious bout of divinely prompted creation. Rather, in my experience, most successful artists are pragmatic and work-obsessed; in a word, rigorous.' [3]

It's a view echoed by the choreographer Twyla Tharp, who emphasises the importance of discipline:

'I come down on the side of hard work. . . creativity is a habit and the best creativity is the result of good work habits. That's it in a nutshell.' [4]

Watching rehearsals at the Kneehigh Barns, I realised I was witnessing one of the secrets of the theatre world – something special, that those not directly involved in a production rarely get to see. I was seeing something take shape – creativity in action. It's a process of collaboration and it's only when you see it happening that you realise just how special, and how hard-won, it is.

A few years ago, when the designer Sir John Sorrell stood up to give a lecture at The Royal Institution, he handed out small red cards to the audience. On one side was printed the word 'Creativity' – the title of his lecture. On the other was the *Oxford English Dictionary* definition of the word:

[3] Perry, Grayson, 'Rigour' in *The Creative Stance* (London: Common-Editions/University of the Arts London, 2016)

[4] Tharp, Twyla, *The Creative Habit: Learn it and Use it for Life* (New York: Simon & Schuster, 2006)

Bringing into existence.

Giving rise to.

Originating.

Being imaginative.

And inventive.

I have one of the cards stuck on the corner of my computer screen as I write these words. Producing this book is in itself a creative process and I find that little card a creative spur, as the ideas and words arise in my head and are shaped on the screen in front of me.

In 2014, John Sorrell returned to the subject of creativity in a book that he wrote with me and Paul Roberts – who, like John, is a leading thinker in the area of cultural education. In *The Virtuous Circle: Why Creativity and Cultural Education Count*, we argue that an excellent cultural education should be a universal right. It brings personal, social and commercial advantages that can benefit the lives of all individuals in society. I'll discuss the education dividends that investment in arts and culture pays back in the next chapter.

First, let's unpick creativity a little more. In many ways, the Creativity Dividend is the most important of all of the benefits that arise from art and culture. It's also the hardest to pin down and to quantify; but, like the lettering in a stick of Blackpool rock, it runs through each of the other six

dividends. I find it's always good to keep in mind the words of the American poet Maya Angelou:

'You can't use up creativity. The more you use, the more you have.'

One of the best ways of understanding the power of creativity is to take a moment to try to imagine our lives entirely devoid of it. This world would be the antithesis of the ideas suggested by the words on John Sorrell's card: nothing would be brought into existence or given rise to; there would be no originating; and people would be neither imaginative nor inventive. In a world without creativity, we wouldn't be able to make improvements to the environment that we live in; we would not have the imagination or inventiveness to resolve the global issues that we all face in the twenty-first century.

Instead, we would be frozen in a hellish form of suspended animation where our only reference points were what had happened in the past and what was happening right now in the present. There would be no hope of any difference or change in the future.

To put it simply, creativity makes the world a better place. It enhances our lives. Through being creative in our approach, we can innovate – we can imagine a better future, and then realise it.

Sir John Hegarty made his name as one of the founders of the advertising agency Bartle Bogle Hegarty. His success in

business was founded on his own creative ideas, but he was also able to spot creativity in other people, which helped him to surround himself with talent. Hegarty wrote that:

> *'Creativity touches all our lives in a thousand different ways, from the clothes we buy to the buildings we live in, from the food we eat to the cars we drive. Creativity invents, perfects and defines our world. It explains and entertains us. Almost every facet of our lives is influenced by it. And its impact is only getting stronger as time goes on. It's not surprising then that we're always being told the future is creative!'* [5]

I have tackled the Creativity Dividend first in this book because it's often the most obvious outcome in the early stages of cultural investment. Great artists bring creativity with them when they roll into town, and that has an effect on everyone they come into contact with. This is not to overlook the enormously important and positive effects of home-grown artists engaging with the place where they were born or grew up. But I think that latent indigenous talent often comes to the fore when it's sparked by the arrival of new creative talent in a community. Artists of all sorts can very quickly alter how a town or city physically looks, and how the people there think of themselves and behave. I'll talk more about this in Chapter 5.

[5] Hegarty, John, *Hegarty on Creativity: There Are No Rules* (London: Thames & Hudson, 2014)

Artists can effect change in the most unlikely of places. This was brought home to me in 2018, when I found myself eating (yet) another delicious supper laid on by a community of artists. The meal had been made by a team led by Alan Lane, the hugely inspirational director of Slung Low theatre company, and it accompanied a cabaret night marking the reopening of the oldest working men's club in Britain, The Holbeck in Leeds, as Slung Low's new home.

The theatre company runs a traditional members' bar in The Holbeck; the rest of the building is an open development space for artists and a place where Slung Low invites other companies to present work that otherwise might not get to be seen in Leeds.

It's a brilliant example of an arts organisation operating in a community setting – but rather than imposing ideas on the community, it is run in a spirit of co-curation. This is something I will return to in Chapter 5, when I discuss the Place-Shaping Dividend. What makes the Slung Low model particularly innovative is their Cultural Community College, which is based on a converted double-decker bus parked outside The Holbeck. It's a place where locals can come to learn

" Creativity makes the world a better place. It enhances our lives. Through being creative in our approach, we can innovate – we can imagine a better future, and then realise it. "

new skills, from stargazing to South Indian cooking and from carpentry to singing in a choir.

A theatre company making its home in a community club was never going to be plain sailing and Alan has written movingly about what they learned during 2019 – their first year based at The Holbeck. But despite all of the challenges, the effect that the Slung Low team have had on their local community has clearly been electrifying:

> 'As a company we've never been more useful. We've never spent our funding more efficiently to reach as many people. We've never taught as many people, entertained as diverse an audience, welcomed as many people who would be welcome nowhere else. We are connected. And – most of the time, on a good day – we are relevant.' [6]

I had first met Alan back in 2015, when Slung Low was based in their original home at the Holbeck Underground Ballroom (known as 'The HUB'), just outside Leeds city centre. It wasn't exactly a glitzy address, at least not in conventional showbiz terms. The HUB was made up of five railway arches in an area you might describe as being off the beaten track, artistically. But it was there that Alan and his team dreamed up innovative and ambitious theatre. And, it would be fair to say, theatre that is sometimes slightly crazy too. But that's the brilliance of its beauty. Their decision to move to The Holbeck in 2018 marked a new deepening of the

[6] https://alanlaneblog.wordpress.com

relationship between the arts organisation and its local community.

In 2015, I watched Alan's production of *Camelot* at the Crucible in Sheffield, which involved the whole audience walking through the city on a Saturday night listening to the action on headsets, with explosions and artillery battles taking place in front of them. I thought I knew the story of *Camelot*, but Slung Low's version was quite unlike anything I have seen. Alan Lane and the writer James Phillips had wholly reimagined it, turning it into a new piece of epic theatre.

Mihaly Csikszentmihalyi (who developed the notion of 'flow' in our lives – those occasions when we become so engrossed in a moment that we lose awareness of time and everything else passes by in a blur) is one of my positive psychology heroes.[7] He notes that constant reimagination is the signature of the creative, across all artistic disciplines:

> *'Each poet, musician, or artist who leaves a mark must find a way to write, compose, or paint like no one has done before. So while the role of artists is an old one, the substance of what they do is unprecedented.'* [8]

[7] Csikszentmihalyi, Mihaly, *Flow: The classic work on how to achieve happiness* (London: Rider, 2002)

[8] Csikszentmihalyi, Mihaly, *Creativity: The Psychology of Discovery and Invention* (London: HarperCollins, 1996)

Now, the logistics of having tanks roll through the streets of Sheffield on a Saturday night in the middle of summer, surrounded by an army of 137 performers from Sheffield People's Theatre, while you act out a contemporary reworking of the Arthurian myths are mind-boggling. There must have been so many potential obstacles. But, working with the creative team at Sheffield Theatres, Slung Low had made it happen. To pull off a performance on this scale in Sheffield took exceptional application and dedication. Far from being a bunch of lazy luvvies, the best creative people demonstrate a greater entrepreneurial spirit and can-do approach than most of the rest of us. It's something that the BBC's arts editor Will Gompertz has noted:

> 'Artists don't seek permission to paint or write or act or sing, they just do it. What tends to set them apart, and gives them their power and purpose, is not their creativity per se – we all have that. Rather, it's the fact that they have found a focus for it, an area of interest that has fired their imagination and provided a vehicle for their talents.'[9]

Alan Lane, James Phillips and the Slung Low team pulled this off again when they created *Flood*, an epic year-long project told in four parts and performed by a professional cast alongside more than a hundred volunteers as part of Hull City of Culture in 2017. The performances took place on boats and floating stages in Hull's Victoria Dock with the

9 Gompertz, Will, *Think Like an Artist... and Lead a More Creative, Productive Life* (London: Penguin, 2015)

audience again listening in to the dialogue on headsets. On the nights I saw the production, the wind may have come howling in off the North Sea, chilling the audience to the bone, but the theatricality of the event certainly warmed my heart and fired up my mind.

I've seen this creative energy described by Gompertz and exemplified by Lane and Phillips in many different cultural environments, not only in those we might think of as traditional arts organisations. Some libraries, for instance, currently face severe financial challenges because of reduced funding from local authorities – but, nonetheless, they continue to evolve and build on their historic role as storehouses of knowledge and information. Today, the very best of their number are creative spaces at the heart of their communities. I saw one good example at FabLab Devon, a small-scale digital fabrication workshop housed inside Exeter Library. It's an open-access, not-for-profit, community resource. It offers people the opportunity to develop new creative skills and learn how to free their own innate creativity – at FabLab, anybody can invent and make just about anything. It's part of reimagining what the libraries of the future will look like.

And stunning creative moments can be woven into our everyday lives in other ways. I still cherish the memory of

❝ *The best creative people demonstrate a greater entrepreneurial spirit and can-do approach than most of the rest of us.* **❞**

standing on the platform at Sheffield railway station on a sunny July morning in 2016 surrounded by silent volunteers dressed in the uniforms of long-dead soldiers who had served in the First World War. They were taking part in *we're here because we're here*, a public artwork created by the Turner Prize-winning artist Jeremy Deller and the National Theatre director Rufus Norris. It happened in towns and cities across the country on an otherwise ordinary Friday to mark the one hundredth anniversary of the first day of the Battle of the Somme. This extraordinary large-scale creative act sparked intrigue, conversation and contemplation, creating a social media storm as commuters, shoppers, schoolchildren and students encountered groups of the soldiers walking in the streets and riding on buses and trains. For me, it perfectly exemplifies the ability of art to make a profound and long-term impact on people's lives.

Talent is everywhere. Opportunity is not

I made my first speech as chief executive of Arts Council England in 2015 at the Ferens Art Gallery in Hull. Two years later, it was home to the Turner Prize as part of Hull's redefining year as UK City of Culture. In that speech, one of the things that I talked about is the need for those involved in art and culture to do more to nurture creative talent across all of England, and for that creative talent to come from all parts of society. Nobody should be prevented from achieving their creative potential because of barriers of ethnicity, faith, disability, age, gender, sexuality, financial deprivation or geography.

Talent is everywhere. Opportunity is not. Not yet. It's a problem, but one I'm determined to do something about.

I was particularly struck by a performance at Somerset House in London, at an event organised by the National Saturday Club. This network of clubs – the brainchild of Sir John and Lady Frances Sorrell – offers young people aged between thirteen and sixteen the unique opportunity to study at their local college or university, for free. The programme originally centred on art and design, but now also includes clubs focusing on fashion and business, science and engineering, and writing and talking.

I was speaking at the launch of the annual exhibition of the work of the young people from across the country who had taken part in the National Art & Design Saturday Club, but I was completely overshadowed by the talents of the other speaker that night: twenty-four-year-old poet George Mpanga, who had been mentoring a group of Saturday Club members from Walthamstow.

George grew up on the St Raphael's Estate in north-west London before studying politics, psychology and sociology at King's College, Cambridge, where he began adapting his rap verses into poetry. Under the stage name George the Poet, he signed a record deal with Island Records. The company's president, Darcus Beese, says of him:

'In this ever hyper-stimulated world, with attention spans decreasing by the minute, George asks us to slow down, listen,

understand and hopefully act accordingly. Important stuff . . .
there's not much more important than that.'

That night, George's recital of his poem 'All Existence is Contribution' was spellbinding – one of the most remarkable performances I have seen during my time at the Arts Council. It made my words seem quite inadequate, because his poem put the case so eloquently for the voices of all parts of our communities to be heard:

'Everyone brings something to the table
But not everyone gets a seat.' [10]

The poem calls for us to recognise the contributions young people from all backgrounds can make to society:

'Untapped potential could be unlocked ability
Hidden wisdom, unsung possibility.
We live in a world that celebrates our young
For being more professional than clever.
As a result, we miss out on a lot of knowledge
At a time when it's more accessible than ever.' [11]

I wanted to hear more. On the train home, I looked George up on the internet and ordered a copy of his first collection of poetry *Search Party*. The anthology includes 'All Existence is Contribution' alongside another thirty or so of his poems.

[10] George the Poet, 'All Existence is Contribution' from *Search Party* (London: Virgin Books, 2015)

[11] Ibid.

I urge you to read it. I also urge you to listen to 'Have You Heard George's Podcast?'.[12] Each episode is a mixture of poetry, commentary and conversation woven together with excellent sound design. It deservedly swept the board at the 2019 British Podcast Awards and was named 'Podcast of the Year'. We've been lucky to have George as a member of Arts Council England's National Council since 2018. I've learned a lot from him; his words are never more powerful than when he challenges my thinking and helps me to see the world from a different point of view. He is still not yet thirty years old and will continue to share his wisdom and insight for many decades to come.

To make sure that we are liberating the creativity of every part of society, we need to have a more inclusive and diverse art and culture sector – and to achieve that we've got to make some fundamental changes. The arts need to reflect the world we live in – and shed light on the world we want to see. We need to understand – as many international businesses now do – that diversity is a major opportunity that we must embrace if we are to thrive. That's what the Arts Council is doing through promoting its Creative Case for Diversity. Rather than treating diversity as a kind of supplementary add-on, or an activity that is supported to run parallel to the mainstream arts and culture world, the Creative Case presents it as being central to the creative process. It is an opportunity to find fresh ideas and new art.

12 https://www.bbc.co.uk/programmes/p07915kd/episodes/downloads

When I talk about diversity here, I am referring to people who possess one or more of the personal characteristics that are protected under the law by the Equality Act of 2010. But I am also addressing the disparities of opportunity that arise through socio-economic and geographic factors. The promotion of diversity is about removing barriers that are faced by too many in our society.

Those barriers to opportunity can come in many forms. The most powerful and moving autobiography that I have read for many years was Lemn Sissay's 2019 memoir *My Name is Why*, telling the story of his childhood in the care system. The book should be required reading for anyone who has a responsibility for any aspect of public policy involving young people. It's devastating, but yet also carries with it a sense of hope. Lemn is a tireless campaigner on behalf of young people looked after by the state – and also on behalf of those who have recently left the care system.

In 2018, we both spoke at a conference organised by Derby Theatre on how cultural organisations can connect with children in care. There's a lot being done already, but I know that there's more we can do to help these young people to achieve their potential. Music, dance, drama, the visual arts, and

❝ *It's important that we celebrate everyone's diversity and the insight, experience and knowledge that people's diverse backgrounds bring to our national creativity.* **❞**

writing poetry and prose can help them do that. The creative arts give them a powerful voice all of their own, helping them to make their mark on the world. Lemn's success as a poet, author, performer and playwright proves the point. We need to make sure that these young people, who have endured a tough start in life through no fault of their own, get the opportunity to shine.

At the same time as tackling disadvantage, it's important that we also celebrate everyone's diversity and the insight, experience and knowledge that people's diverse backgrounds bring to our national creativity. The more diverse we are as a community, the more creative we become. We need to ensure that the people involved in every level of the commissioning process are an accurate reflection of the way England looks and feels in the twenty-first century – those being commissioned, those doing the commissioning, and those funding it. That way we can make sure that the resultant art and culture is also properly representative.

It's an area of our work that has been championed by both of the Arts Council England chairs for whom I have worked: Sir Peter Bazalgette and Sir Nicholas Serota. Baz has often spoken passionately about the Creative Case for Diversity, setting out his vision for what needs to change:

'If we make this work, diversity – and I'm talking ten years from now – will no longer be an aspiration. It will be a reality. Young talent, whatever its background or class, will see the kind of work that convinces them that the arts belong to them

– and that they have a way in. They will seek careers on the technical side; in administration; as performers; creators and, crucially, as leaders. If we do this properly, we'll have flourishing centres of creativity throughout our cities with work that inspires, enriches and broadens our horizons. Creative work that liberates the energy of our nation.'[13]

Nick has developed the argument further during his time as chair of Arts Council England, reminding us of the need to focus on people from tougher socio-economic backgrounds alongside the protected characteristics enshrined in law:

'Economists see our young, diverse population as a national asset, representing a multitude of perspectives, ideas, talent and creativity. But the recent report by the Social Mobility Commission highlights how very much harder it is becoming for young people to overcome the socio-economic barriers that hinder progress. As a society, we are denying opportunity to this young generation. We aren't making the most of this valuable national asset, and are obstructing our own progress as a consequence. More must be done to help all young people realise their potential. For the arts, that means working in communities where disadvantage is common, to break down the socio-economic barriers. We want to widen access to cultural institutions, and will continue to push for greater representation within the arts across race, disability, gender and sexual orientation. The arts are intrinsically a social medium, where we

[13] https://www.thestage.co.uk/news/2014/ace-diversity-push-peter-bazalgettes -important-speech-full/

exchange creative ideas and skills, and form the basis of mutual understanding. It should be an inclusive world, not a bastion of privilege. A building open to all, not an exclusive club.'[14]

Having leadership role models who more accurately reflect our society is one of the key changes we need to continue to make. After all, it's the people who lead arts organisations who are the ones making the creative decisions. They're deciding what to create and they're choosing who is going to create it. It's clear that we need a more diverse leadership across the arts and culture world, in our arts organisations, museums and libraries. The current leadership simply doesn't reflect the diversity of our nation and this in turn is impacting negatively on who is being commissioned. The onus is on all of us who are currently in positions of influence to ensure that the next generation of leadership talent is more reflective of our nation.

During my visits to Bradford over the past few years, I have always been left buzzing with excitement by the Bradford Literature Festival, under the indefatigable leadership of Syima Aslam. Its artistic programming has created one of the most diverse UK literary festivals, with the aim of reflecting the work of people from all communities. With investment backing from Bradford University, Bradford Metropolitan District Council and Arts Council England plus significant financial sponsorship from Provident Financial Group, Syima

[14] https://inews.co.uk/opinion/nicholas-serota-one-day-diversity-arts-will-not-unusual-514986

and her team have created a cultural and literary extrava-
ganza that consistently exceeds even their high expectations.
They've succeeded in creating a literature festival designed
for everyone in the city.

Arts Council England's headquarters is in Manchester's
Northern Quarter, so I spend a lot of time in the city. I always
enjoy my visits to the Royal Exchange – a theatre unlike any
other I've seen. Originally it was a trading hall where, at the
beginning of the twentieth century, some 80 per cent of
the world's finished cotton was bought and sold. Today it is an
attractive Grade II listed building, but walk through its front
doors and you will find the cavernous old trading hall occu-
pied by what appears to be a rather large spacecraft. In fact,
this futuristic-looking structure houses the country's largest
theatre in the round. I'm always pleased to see that rather
than being all white, the casts are an accurate reflection of
the life you'll see on the streets of Manchester. I had seen
people from different ethnicities walking past a nearby café
before the show, so why should it be any different onstage?

Actors should be cast on their talent. I thought that the author
J. K. Rowling dealt with this brilliantly when questions were

*❝ Having leadership role models who more
accurately reflect our society is one of the key
changes we need to make. After all, it's the people
who lead arts organisations who are the ones
making the creative decisions. ❞*

raised over the casting of the black actor Noma Dumezweni as Hermione when the *Harry Potter and the Cursed Child* play was first staged at London's Palace Theatre. Of course, Dumezweni looks different from the white actor Emma Watson, who played the character in the films. Rowling, who let's not forget, actually created the character, put paid to the social media debate in one simple tweet:

'Canon: brown eyes, frizzy hair and very clever. White skin was never specified. Rowling loves black Hermione.'[15]

Of course, the colour of an actor's skin shouldn't be something that needs to be remarked upon here. But I believe I must, because there is still a long way to go in the creative industries to ensure that our workforce is sufficiently reflective of the way England looks today. I want us to reach a place where having diverse actors, writers and directors is literally unremarkable – simply a matter of course. We need to make sure that all people from all backgrounds are *included* in the creation of great art and culture. This was neatly encapsulated for me by the diversity consultant John Dyer in a presentation he gave at the No Boundaries conference at Manchester's HOME arts complex in 2015:

'Diversity is inviting someone to a party. Inclusion is asking them to dance.'[16]

15 https://twitter.com/jk_rowling/status/678888094339366914?ref_src =twsrc%5Etfw

16 Dyer, John, Presentation to 'No Boundaries' conference. HOME, Manchester (30 September 2015)

If we want to change and broaden the audiences for the arts and for cultural activities, we need to make sure that a significant proportion of the people who are making and fronting the artistic activities reflect the potential audiences that we are not reaching.

This was clear to me when I watched *The Etienne Sisters* at the Theatre Royal Stratford East, located in the heart of London's East End on the edge of the Olympic Park. This new play written by Ché Walker had a brilliant young all-female cast made up of Allyson Ava-Brown, Jennifer Saayeng, Nina Toussaint-White and Nikki Yeoh. As I looked around the auditorium, I could see that by putting a story like *The Etienne Sisters* onstage and presenting it with integrity, this theatre was truly connecting with the 'vibrant, young and diverse audience' targeted in its mission statement. The audience reflected the mix of people who live in Stratford. At that moment, I realised that getting diversity right isn't rocket science. Which makes it all the more perplexing that we haven't yet got it right.

This thought came back to me when I was sitting in London's Queen Elizabeth Hall in September 2015 for the inaugural performance of the Chineke! Orchestra. Founded by the leading double bass player Chi-chi Nwanoku, Chineke! provides top-class opportunities to established and up-and-coming Black and Minority Ethnic classical musicians in the UK and Europe. Our major symphony orchestras in this country still have a long way to go to reflect onstage the ethnic diversity of the communities within which they are located – so Chi-chi's

work in championing change and celebrating diversity in classical music is both important and necessary.

This lack of diversity is something that Stuart Murphy, the chief executive of English National Opera and the London Coliseum, has vowed to change with the launch in 2020 of a new strategy for nurturing talent from Black, Asian and Minority Ethnic backgrounds, including the recruitment of new performers to ensure that the members of the ENO chorus and orchestra are more representative of the UK population.

Since taking over as the artistic director of another of London's excellent theatres – The Kiln Theatre in Kilburn – Indhu Rubasingham has garnered rave reviews for her inclusive artistic programming. She is clear about why her strategy has paid dividends and why it should be more widely adopted:

'I believe that different, diverse stories are popular enough to attract all audiences and not just "new" ones and therefore they will make money. That is a pragmatic way to demonstrate the importance of diversity in our industry. Without that diversity we shall become mono-cultural, alienating and soon irrelevant. We need to take both small and large steps to ensure we encourage the best talent all around us. By this I mean we have as a whole ecology – across education, the arts and media – a responsibility to inspire, encourage and nurture talent where we least expect to find it. We need to be proactive, open and less fearful of taking risks. This will empower a diversity of tastes, a tapestry

of stories, with ideas clashing, conflicting, collaborating – all of which is needed for our arts scene to be world-leading, rich, vital and relevant.'

Aside from the moral and creative arguments for diversity – which should be reasons enough – there are clear financial gains for cultural organisations too. This was noted in the 2015 report by the Warwick Commission on the Future of Cultural Value:

'Diversity of creative talent and participation is essential to the expressive richness and the economic and social prosperity of the ecosystem. It is a mistake to think that the under-representation of Black, Asian and Minority Ethnic individuals, women, deaf and disabled people and low-income groups in the Cultural and Creative Industries is purely a social justice issue.' [17]

Inclusion isn't just an issue in the theatre. The museum world has a big job to do in terms of the diversity of its workforce, so when I toured the Black Cultural Archives in Brixton, it was good to learn of their training programme, which has seen young people from Black, Asian and Minority Ethnic backgrounds go on to further education to train as professional museum curators.

There's still a long way to go to ensure that D/deaf and disabled people are properly represented in our creative

[17] Warwick Commission on the Future of Cultural Value, *Enriching Britain: Culture, Creativity and Growth*, University of Warwick (2015)

industries. Organisations such as London-based Shape Arts have pioneered much of the thinking and action that has resulted in the greater inclusion of disabled artists in arts organisations such as the Royal Opera House, the National Theatre, Tate and the Southbank Centre. But there remains much more to do, if we are to bring disabled artists into the mainstream of all arts and culture organisations.

The government's disability champion for the arts and culture, Andrew Miller, uniquely sits on the national councils of both Arts Council England and Arts Council of Wales. I share his determination to see greater equality for disabled people, whether they be cultural practitioners, or members of the public:

> *'This is about ensuring disabled people are welcomed and valued as artists, employees and audiences – as equals. I want to see our cultural sector leading beyond the requirements of the Equality Act, to demonstrate that poor training, rubbish access and institutional discrimination can be consigned to the past.'*[18]

Although physical differences are more visible, there are many other differences that we all possess as human beings – not least the way we think. At the beginning of 2020, the Chairman and CEO of Universal Music UK, David Joseph (another member of Arts Council England's National Council), published *Creative Differences: A*

[18] https://www.thestage.co.uk/opinion/2019/andrew-miller-disability-can-no
-longer-exist-bottom-list-arts-priorities/

handbook for embracing neurodiversity in the creative industries.[19] Neurodiversity refers to the infinite number of ways in which our brains function that lead to differences in thinking, attention and memory. Autism, dyslexia, dyscalculia, dyspraxia and Tourette Syndrome are among the variants of neurodiversity that are most often talked about.

As the head of the UK's most successful record company, David Joseph has spent his career working with highly creative individuals. He believes that creating the most inclusive working environment for everyone is the right thing to do – both for the individuals concerned and also for any organisation that values human creativity:

> *'We believe the best way to flourish in our ever-changing industry is to create a team that truly reflects the incredible diversity of our artist roster and society. While progress has been made in many areas, there has been little exploration around the importance of neurodiversity. We looked for a practical guide to help us do what was needed. When we couldn't find one, we decided to create one and share it, and that's why we launched the Creative Differences project. Our overall conclusion is that making your organisation ND-friendly is to the benefit of your entire workforce. Everyone should feel comfortable in bringing their whole selves to work.'*

David is absolutely right in his deeply held belief that creative humans are everywhere in our society. And he's also correct

[19] https://umusic.co.uk/Creative-Differences-Handbook.pdf

in his assertion that many struggle to achieve their potential. For too long, some people have been handed an unequal deal in the workplace – even when their talent wasn't in doubt – simply because they think differently.

Rather than just talking about the problem, David and his team at Universal Music decided to take action. They were typically thoughtful and sensitive about the way in which they went about considering the challenge. In producing their handbook, they listened to a lot of advice from experts. But, most importantly, they worked collaboratively with people with lived experiences to ensure that everything it contained was authentic and useful.

The handbook highlights that while nearly all creative companies recognise the value of neurodiversity in the workplace, only very few have neurodiverse-friendly policies and practices in place. It goes on to provide a range of practical solutions companies can adopt to attract, support and retain neurodiverse talent in areas including recruitment, mentorship and career progression. Specific recommendations include neurodiversity awareness education for all employees, providing flexibility around the job application process and also some less obvious suggestions such as a

“ *There's still a long way to go to ensure that D/deaf and disabled people are properly represented in our creative industries.* **”**

buddy system to help new recruits better understand unwritten social rules.

The handbook is a powerful moral argument for everyone being able to achieve their personal potential at work; it's also eloquent in making the business case for more inclusive ways of operating. If the advice shared within its pages was to be adopted across the creative industries, more people would be able to flourish more often in more places. Not only is that good for business, but it's good for people too, enabling more of us to enjoy the happy and fulfilled lives that we all deserve. David's message to the people who work with him at Universal Music is 'Come as you are'. This lovely, simple phrase neatly encapsulates the entire philosophy of his Creative Differences project. If we all applied these words to all parts of society, rather than focusing on other people's differences, our world would be a happier place.

One of the things that I have become fascinated with since I've been at the Arts Council is the way in which the language we all use – and, in particular, the words we apply as labels – can carry powerfully positive or negative meanings for different people. Universal Music's work around neurodiversity underlined this for me, as did the words of Jo Verrent, the senior producer for Unlimited, an arts commissioning programme supported by Arts Council England that enables new work by disabled artists to reach UK and international audiences. Jo believes that 'different' is 'delicious not divergent'. I reckon that there's a lot to be said for her definition and, once again, the world would be a happier place if we all

applied it to the societal, cultural and national differences that we encounter in our lives every day.

Ultimately, we have to recognise that it's the prevailing attitude within society itself that creates barriers to change, not those who are perceived as disabled. We need to start talking about 'enabled' rather than 'disabled' people in arts and culture. This is another important way in which creativity can be freed and through which we can make England a more creative place.

That's why I am particularly excited by Ramps on the Moon, an ambitious theatre project that has been running for the past five years, with more than £4 million of Arts Council funding. It involves the New Wolsey Theatre in Ipswich, Birmingham Repertory Theatre, Theatre Royal Stratford East, Nottingham Playhouse, Leeds Playhouse and Sheffield Theatres. All are working with Graeae Theatre, a company led by inspirational artistic director Jenny Sealey, which has made its name by providing a platform for D/deaf and disabled talent by unambiguously placing disabled artists centre stage.

This project has created a series of new pieces of high-quality touring theatre – with more to come. Disabled people are at the heart of the work. Access is built into the fabric of

“ We need to start talking about 'enabled' rather than 'disabled' people in arts and culture. ”

the creative process, whether working with sign performers, animating screen projections or incorporating live audio descriptions. Each year, one venue produces a show which then tours to the others, giving all the organisations direct experience of working with disabled artists and of learning how to develop disabled audiences. This helps each theatre to understand more about ways of including disabled people in everything they do in the future, creating a collaborative circuit of regional theatres and tackling lower levels of attendance by disabled audiences.

So far, I've caught three of their productions: *The Government Inspector* in Birmingham, *The Who's Tommy* in Ipswich, and *Our Country's Good* in Stratford. And I'm hoping that Ramps on the Moon will prove to be just the start of a major movement to bring a far greater number of talented disabled actors into the mainstream theatre world. I also hope that the learning from the programme will continue to be transferred into other art forms alongside the theatre.

Although we may have a long way to go, there are nonetheless beacons of excellent practice across many art forms – including the visual arts and music. There is some great thinking and practice, for example, emanating from Intoart in Brixton. This visual arts charity helps adults and young people with learning disabilities to establish themselves as artists whose work is taken just as seriously as that by artists who do not have learning disabilities. I urge you to look out for their regular exhibitions at some of London's most significant private and public galleries.

The Bristol-based British Paraorchestra is another organisation redefining the boundaries of a particular art form – in this case, the symphony orchestra. Under the direction of their conductor, Charles Hazlewood, they are the world's only large-scale ensemble for professional disabled musicians. With performances at the BBC Proms, the Glastonbury Festival and in concert halls around the country, Hazlewood is evangelical about the importance of the orchestra's work:

> *'I conduct orchestras around the world, and I can count on the fingers of one hand the number of musicians with a disability I have encountered anywhere. There is no platform for musicians with disability, very little in the way of funding – and therefore access to the often-necessary technologies: it is virtually impossible for anyone from this community to make a living as a professional musician.'*

Bristol is becoming something of a trailblazer in this important area, as it's also home to OpenUp Music, a community interest company that creates musical instruments playable with any part of the body, including the eyes. This is transformative, particularly for many young people with special education needs. When I saw a performance by one of their Open School Orchestras in Bristol, I was impressed both by the music, and by the opportunity it gave young disabled musicians to explore and develop their musical experience. The team at OpenUp are helping to raise aspirations for young disabled people, and are showing how exciting it can be when music education projects are made accessible to everyone. They have now set up the South-West Open

Youth Orchestra, the UK's only disabled-led regional youth orchestra, which is delivered in partnership with musicians from the British Paraorchestra. It's an area of work that I hope will continue to grow fast over the coming years.

The lack of D/deaf and disabled talent on our stages really came home to me when I was at Warwick Arts Centre watching a performance of *The Deranged Marriage* – a very funny play written and directed by Pravesh Kumar and produced by the Watford-based British Asian theatre company Rifco. One of the characters is D/deaf and communicates with his brother using sign language throughout the play. Nobody onstage mentions it and it's not part of the plot. It just happens that he is D/deaf – in the same way that some people we meet in real life just happen to be D/deaf. It was unremarkable. I loved *The Deranged Marriage* anyway. But I loved it even more for that – for reminding me what life is like.

the learning dividend

in brief . . .

Investment in cultural education will deliver long-term dividends to the UK's talent pipeline. Studying subjects such as art and design, dance, drama and music in the classroom should be a part of every child's education throughout their schooling. They should also have opportunities to take part in formal and informal cultural education activities outside the classroom. The benefits are wide ranging, developing a child's knowledge, understanding and skills, nurturing their imagination and developing their ability to explore new possibilities. This in turn allows their confidence to grow, helping them to build their own sense of self as they come to understand their place in the world. We need to ensure that there is enough investment to make high-quality cultural education a part of every child's life no matter what their background – only then will the full benefits of this dividend be realised.

The children are our future

As I've travelled around the country, I have held scores of round-tables with artists and leaders of arts organisations, museums and libraries. I've never counted them up exactly, but the number of conversations about culture I've personally had with audience members and practitioners of one sort or another all over England now runs well into the thousands.

One of the most interesting and thought-provoking discussions I enjoyed was at the University of Kent's Gulbenkian Theatre, perched high on a hill overlooking the cathedral city of Canterbury. It's home to ART31, an arts movement for anyone aged between thirteen and twenty-five. With the aim of showing just how much young people can achieve for themselves, the members of ART31 are encouraged to decide what events they would like to create and then to make them happen. Along the way, they pick up valuable skills as arts practitioners and technicians – and learn about how arts policy is shaped. Their name comes from Article 31 of the United Nations Convention on the Rights of the Child, which states:

> *1. States Parties recognize the right of the child to rest and leisure, to engage in play and recreational activities appropriate to the age of the child and to participate freely in cultural life and the arts. 2. States Parties shall respect and promote the right of the child to participate fully in cultural and artistic life and shall encourage the provision of appropriate and equal opportunities for cultural, artistic, recreational and leisure activity.*[1]

[1] https://www.unicef.org.uk/what-we-do/un-convention-child-rights/

The ART31 members told me about the importance that studying curriculum arts subjects at school, college or university had in their lives, both in terms of preparing them for future careers and in giving them valuable skills that they put to good use in other areas. Attending ART31 at the Gulbenkian was, for many of them, the highlight of their week and they told me how they planned their many other school commitments around their artistic activities.

Bright, articulate, challenging, thoughtful; these young people wanted to be sure that funders like the Arts Council would be investing in arts and culture that was relevant to their lives. They wanted to be certain that we understood the newest technology and how people in their teens and twenties used that technology to connect with and enjoy cultural activities. And they were very clear about the importance of studying arts subjects in schools. They regarded it as an absolute right rather than a privilege. It reminded me of a story that the artist Howard Ikemoto told about his daughter:

> *'When my daughter was about seven years old, she asked me one day what I did at work. I told her I worked at the college – that my job was to teach people how to draw. She stared back at me, incredulous, and said, "You mean they* forget?*"'* [2]

With the clarity that only a child can possess, Ikemoto's young daughter had realised for herself that creativity is embedded in all of us. But her father's job working with students was

[2] Bayles, David and Orland, Ted, *Art & Fear: Observations on the Perils (and Rewards) of Artmaking* (Eugene, OR: Image Continuum, 1993)

about taking that creativity further. We need to be taught how to develop and hone our creative skills and this requires investment – of time, of money and of expertise. It all starts with investment in children and young people and in their cultural education.

When we make the right investment in art and culture, at the right time in childhood, we reap the second of our benefits – the Learning Dividend. And it pays back long after that young person ceases to be a child, with a multitude of further related dividends throughout their adult life.

Some young people will learn about art and culture – how to create it, enjoy it and appreciate it – and it will enrich their lives intrinsically, as discussed in the previous chapter. Others will learn skills that they will put to good use in whatever walk of life they end up pursuing. Some, meanwhile, will end up with careers that directly utilise their learning from studying cultural education subjects. All three outcomes are equally valid, but they can only be outcomes if cultural education actually forms part of a young person's life.

Let me be unambiguous here: every child should benefit from the opportunity to study cultural education subjects

❝ When we make the right investment in art and culture, at the right time in childhood, we reap the second of our benefits – the Learning Dividend. ❞

to a high level in the classroom throughout their schooling. In addition, they should have access to a rich and varied set of opportunities to enjoy artistic and cultural activities outside of the classroom. Some of their cultural education should be formal; some informal. All children should be offered high-quality opportunities in school and out of school.

The Learning Dividend could just as easily be labelled the 'Education Dividend' or even the 'Knowledge Dividend'. Learning spreads across a lifetime, but in my mind, the most important time for cultural learning is during childhood. Cultural education is a key that can unlock the whole of a human being's future. And properly resourced, high-quality cultural education is central to helping young people discover the possibilities of what they can achieve in the future.

Towards the end of 2019, the Durham Commission on Creativity and Education reported its findings. This thoughtful and wide-ranging study resulted from a collaboration between Durham University and Arts Council England, chaired by Sir Nicholas Serota. In his introduction to the Commission's report, Nick made it clear that an education filled with creativity was not a straightforward binary alternative to a knowledge-based education. Indeed, a strong education was in fact a blending of the two:

> *'There need be no conflict between knowledge and creativity in our education system. Indeed, the opposite is the case – creativity is founded on deep understanding. Every meaningful creative breakthrough in human history has been made by people with*

> *deep expertise, immersing themselves in the practices and prob-*
> *lems of the field and finding new ways to see, act or behave.'* [3]

The report argues persuasively that creativity should span all subjects across the curriculum, noting that we have much to learn in this country from Finland, Australia, Singapore and Canada, all of whom are building creativity-focused education systems. Nick is clear that we owe it to the next generation to ensure that our thinking about what sort of education they receive keeps pace with other forward-thinking countries around the globe:

> *'Children born in the UK today can expect to live for as much*
> *as 100 years. They are likely to witness immense change and*
> *face great challenges. An education that stimulates their creativ-*
> *ity can help them thrive, enjoy, and achieve in their lives, and*
> *shape a better future for themselves, as well as for the nation*
> *as a whole.'* [4]

It's not an accident that the UK has seen its creative industries grow at a rate of 53.1 per cent between 2010 and 2017 – much faster than the 29.7 per cent increase in the economy as a whole during the same period.[5] It's precisely because of a sustained investment in the talent pipeline over the past twenty years that we are reaping the benefits now. It's vitally important that we continue to invest more – not less – in

[3] https://www.dur.ac.uk/resources/creativitycommission/DurhamReport.pdf

[4] Ibid.

[5] https://www.thecreativeindustries.co.uk/resources/infographics

children and young people's creative and cultural education. That's the only way to make sure that our creative industries remain such a successful growth area.

The benefits of cultural education

The Learning Dividend has huge benefits for society as a whole. Over the past decade, there has been a good deal of research into how engagement with arts and culture has a positive effect on young people's educational attainment, as well as how it improves outcomes later on in their lives. The Department for Digital, Culture, Media and Sport's 'Culture and Sport Evidence' programme (CASE) published two reports on the subject. These concluded that learning through arts and culture improves pupils' attainment across many parts of the school curriculum, as well as having other benefits for young learners.[6] The conclusions were summarised by Arts Council England in a report entitled 'The Value of Arts and Culture to People and Society'. They show that:

- *Taking part in drama and library activities improves attainment in literacy.*

- *Taking part in structured music activities improves attainment in maths, early language acquisition and early literacy.*

6 The Culture and Sport Evidence Programme: 'Understanding the Drivers, Impact and Value of Engagement in Culture and Sport', Department for Digital, Culture, Media and Sport (2010) and 'Understanding the Impact of Engagement in Culture and Sport: A Systematic Review of the Learning Impacts for Young People', Department for Digital, Culture Media and Sport (2010)

- *Schools that integrate arts across the curriculum in the US have shown consistently higher average reading and mathematics scores compared to similar schools that do not.*

- *Participation in structured arts activities increases cognitive abilities.*

- *Students from low-income families who take part in arts activities at school are three times more likely to get a degree than children from low-income families that do not engage in arts activities at school.*

- *Employability of students who study art subjects is higher and they are more likely to stay in employment.*

- *Students who engage in the arts at school are twice as likely to volunteer than students who do not engage in arts and are 20 per cent more likely to vote as young adults.*[7]

So what do we mean by cultural education?

Cultural education spans a wide brief and there is no universal definition of exactly what it encompasses. For the purposes of this book, I consider cultural education to include: archaeology, architecture and the built environment, archives, craft, dance, design, digital arts, drama and theatre, film and cinemas, galleries, heritage, history, libraries, literature, live performances, museums, music, poetry and the visual arts.

[7] 'The Value of Arts and Culture to People and Society', Arts Council England (2014)

In *The Virtuous Circle*, our book about the benefits of creativity and cultural education, John Sorrell, Paul Roberts and I identify the four elements of cultural education. The first is knowledge-based and teaches children about the best of what has been created (for example, great literature, art, architecture, film, music and drama). It introduces young people to a broader range of cultural thought and creativity than they would be likely to encounter in their lives outside school. The second part of cultural education centres on the development of analytical and critical skills, which can also be applied across other subjects. The third element is skills-based and enables children to participate in and create new culture for themselves (for example designing a product, drawing, composing music, choreographing a production, performing rap poetry or making a short film). And the fourth element centres on the development of an individual's personal creativity, which I discussed in the previous chapter.

Delivering all four of these elements requires us to address two distinct, but not contradictory, challenges.

The first is about ensuring that every child has access to cultural education. To my mind, the primary purpose of education is to create well-rounded human beings who have the capacity to think new thoughts, to solve apparently insurmountable problems, and to contribute to society by enriching the world around them in every conceivable way. As the Cambridge University professor, and Britain's best-known classicist, Mary Beard pointed out to her Twitter followers on the day that A level results were published in

England in 2017, studying is not just about young people getting a well-paid job, it's about them getting an education – and that is a valuable end in itself.

As somebody who has returned to formal academic learning myself in the past few years after a gap of around a quarter of a century, I have to admit that I have discovered a much stronger love of learning than I ever had in my teenage years and early twenties when I was ready to leave academia to make my way in the world of the media. So, I am also now a big fan of making lifelong learning available to everyone, no matter what course their previous life journey has taken.

For everybody to be able to make their own creative contribution to society, we must value everybody's creativity, no matter who they are, where they live, or what their background. This is one of the central themes of *Let's Create*, Arts Council England's new ten-year strategy for the arts, museums and libraries from 2020 to 2030.[8] The rich diversity of our nation is one of our great strengths, but we still need to do more to ensure that everyone from every background has an equal chance of their own creativity being widely recognised, developed, understood and valued.

A nation is built around its shared culture: equality of access to that culture strengthens it by ensuring that a huge number of different voices are heard. It gives everyone a chance to succeed, no matter where they start in life.

8 https://www.artscouncil.org.uk/letscreate

Everyone should be a cultural insider, understanding what is said and being familiar with what is meant. But that means that they have to have access to the same points of reference as those people who are already cultural insiders. If a young person doesn't get the chance to read that book, to encounter that music, theatre or dance performance, or to visit that gallery, museum or library, then they're already at a disadvantage to those other, more fortunate young people who do get to experience these activities as part of their education, or because they happen to have been born into families where taking part in cultural activities is regarded as a perfectly normal part of everyday life.

Prince George may currently only be a small boy, but one day he will be our king. In September 2017, he started his formal education at Thomas's Battersea, an independent school in south London. His sister, Princess Charlotte, joined him there two years later. The very first page of the school's website proudly proclaims that the school offers a 'rich and broad curriculum' with 'Art, Ballet, Drama, ICT, French, Music and PE all taught by specialist teachers from a child's first day at school'. The young Royals' parents, the Duke and Duchess of Cambridge, are to be warmly applauded for actively choosing an education for their children that is rich in creativity.

Early years provision has become an increasingly important focus for the Duchess's public work – as has a commitment to the arts in young people's lives. Through the Duke and Duchess's Royal Foundation, she has brought academics,

practitioners and charities together to form a steering group to develop a new body of research and activities to help provide children with the best possible start in life. In a speech in 2018, she underlined her commitment to this cause:

> *'We know how important childhood is; and how the early years shape us for life. We also know how negative the downstream impact can be, if problems emerging at the youngest age are overlooked, or ignored. It is therefore vital that we nurture children through this critical, early period.'* [9]

As I travel around the country by train, I often notice posters advertising local private schools on railway station platforms. In nearly every case, these schools give equal billing to their focus on art, music, drama and sport alongside academic attainment. Given that the parents choosing to send their children to independent schools are prepared to invest six-figure sums into their young people's education, it is clear that they are actively opting for this mixture of creative subjects and what might more traditionally be described as 'academic' subjects, rather than a knowledge-based curriculum alone. To be clear here, I am not in any way against the acquisition of knowledge; it's vitally important. But it is only one part of the full education package. The emphasis on cultural education subjects in independent schools is noted by the CBI in its 2019 report 'Centre Stage: Keeping the UK's creative industries in the spotlight':

[9] https://www.royalfoundation.com/programme/early-years/

'Currently, there is disparity between the availability of creative subjects in state and private schools. Every person from every background must be given the opportunity to engage in creative education, alongside STEM, digital skills and entrepreneurship, to achieve their potential.' [10]

Sadly, for many children and young people from minority communities and from the least prosperous parts of our society, the arts aren't part of their lives in the same way as they are for those young people who attend independent schools. That exclusion holds back their progress. They too should have opportunities to enjoy art, dance, drama and music, taught by specialist teachers, as part of their school curriculum. To do otherwise would be to sanction a huge waste of our national talent, at a time when I would argue we need it more than ever. And if we truly wish to use all our talent, to offer opportunity for all, and to increase social mobility, then access to art and culture must remain high on the agenda for all young people. It's only then that we will all reap the full benefits of the Learning Dividend.

That's not to say that there aren't many excellent state schools around the country, staffed by brilliant teachers, where the arts, creativity and cultural activities are a central part of students' lives. Over the past five years, I have visited a series of impressive schools that have been recipients of silver, gold and platinum Artsmark Awards. This quality standard, administered by the Arts Council, provides a framework for teachers

[10] https://www.cbi.org.uk/media/3857/12527_creative-industries_hyperlinks.pdf

to plan, develop and evaluate the cultural provision in their school. The awards celebrate a school's commitment to creativity and to inspiring students through the arts and cultural education subjects.

Of all the schools I've visited, two particularly stick in my mind. At Anderton Park Primary in the inner-city Sparkhill area of Birmingham, a group of ten-year-olds sparkled as they shared their love of Shakespeare with me. Meanwhile, at Bottisham Village College in rural Cambridgeshire, the teenagers were full of enthusiasm for what they had learned in their dance, drama, music and art classes. In both schools, it was clear to me how much the young people gained from studying new and historical works – and from their involvement in creating art and participating in performances for themselves. Thanks to visionary leadership and excellent teachers, I came away convinced that these two schools had successfully instilled a love of creativity into their students that would remain with them for a lifetime.

What those teachers in Sparkhill and Bottisham know – and what those young people in both schools have quickly found out for themselves – is that reading a book, listening to music, watching a piece of theatre or a dance performance, looking at a work of art, visiting a museum or a library can all be life-enhancing experiences. They represent a wonderful voyage of discovery that we can enjoy throughout our lives.

For those of us already on that journey, even if we are the most voracious of arts consumers, there are still so many

books unread, so many pieces of music unheard and so many museums and galleries unseen. And the good news is that new works of art are being created every day. Our appetites can never be fully sated in any case. It's a never-ending journey, where we cannot know the delights waiting around the next corner, not least because many of them have yet to be imagined by the artist who will go on to create them.

For many young people, the journey really gathers pace when they experience a particular piece of art at a particular moment in time that sparks a lifetime of enthusiasm for a genre or for a subject. It can spur them on to find out more by sampling an increasing variety of experiences – some similar, some very different. But, unless they actually have the opportunity to experience that initial moment of connection, whole areas of culture could well remain closed to them forever. We therefore need to enable and encourage young people – and their families – to enjoy high-quality cultural experiences throughout their childhoods.

However, for their own personal creativity truly to flourish, a young person requires more than just a set of cultural experiences; they need to create their own art too. Being an audience member is only one half of the creative opportunity from which everyone – and particularly young people – should be able to benefit. Writing a story; composing a song; acting in a play; dancing in an ensemble; directing a film; painting a picture: the physical act of making something new is often an even more magical experience than watching someone else do it in front of your eyes, however good an artist they might be.

We need to remember that for those from the poorest backgrounds, the greatest chance they have of accessing art and culture – and of having their eyes opened to their own personal creativity – will be in their schools. That's because attendance at school remains the only activity undertaken by virtually all children in this country. It's only by teaching art and design, dance, drama and music as part of every school's classroom-based curriculum – for the smallest child in a nursery class right through to those in the mid-to-late teens – that all young people can be guaranteed access to these subjects, thereby increasing their chances of becoming cultural insiders.

It's a necessity that these subjects are taught as part of the curriculum. If we shift cultural education to the margins, making it an extracurricular activity, those from the poorest socio-economic backgrounds will be the most likely to miss out. And if subjects such as art and design, dance, drama and music are no longer offered as part of the core curriculum, schools will no longer have a requirement to employ teachers who are specialists in these subjects, meaning that both classroom lessons and extra-curricular activities will suffer.

So, we should now be creating an education framework that encourages more young people to study subjects such as art and design, dance, drama and music at GCSE alongside English, maths, science and languages. We need to ensure that the young people leaving our schools are fully rounded individuals, who are creatively equipped for the world of work. We must have an education system that opens the doors of possibility to our young people, rather than shutting down

their options too early by forcing them to take a narrow set of subject choices that excludes these important aspects of cultural education.

To help make this happen, I believe that our education system should place far greater importance on the value that expert cultural education teachers bring in sharing knowledge, skills and understanding of their specialism, and often of their own creative practice too. I was thrilled to see recognition for the inspirational work of Andria Zafirakou, an art and textiles teacher at Alperton Community School in the London borough of Brent, when she was named the first UK winner of the Varkey Foundation Global Teacher Prize in 2018. Andria was chosen from more than 30,000 applicants from 170 countries to secure the $1-million award. In her eloquent acceptance speech she made a powerful case both for specialist subject teachers and for her own subject, reminding the global audience that:

'Too often we neglect this power of the arts to actually transform lives, particularly in the poorest communities.'[11]

Another challenge of delivering an effective cultural education centres around how a young person progresses during their time at school and beyond. If a young person shows an exceptional level of ability in a subject, we have to make sure that there is a suitable training pathway to take them to the highest level of achievement.

11 www.bbc.co.uk/news/education-43422199

In effect, I'm talking about offering a programme of elite training right through school into further and higher education. Some people will worry about the word 'elite' and accuse such programmes of being 'elitist', but so long as the pathways to the top are open to all then I don't think such a charge will stick. Elitism only comes into play when routes to the best training and education are closed off not on grounds of talent but on the basis of who you are and where you come from. We need to work hard to ensure that any programmes we put in place reward all talent regardless of social background.

As I discussed in the previous chapter, whatever a person's background, they have an equal chance of possessing talent. What is unequal is the chance of their talent being fully realised, particularly when they come from the most economically and socially deprived parts of society. I've said it many times before and I am sure that I will have to say it many times again: talent is not exclusive. It's inclusive. Talent is everywhere. Opportunity is not.

Of course, as with each of the dividends I describe in this book, those of us who believe in them should always caution ourselves against over-claiming. Cultural education alone is not a silver bullet that can miraculously and instantaneously cure all of society's ills. Nevertheless, it really can and does make a difference. But it's worth underlining at this point that there is no magic wand that can be waved to make the world change overnight for children from our most disadvantaged communities. It's by no means easy to put in place the conditions needed to help these young people unlock the

opportunities that will enable them to fulfil their potential. But that doesn't make it any less worth doing. It just means that we need to recognise that it will take time for the investment to come good.

It's not automatic that every child will make an instant connection with every art form. The leading educationalist Sir Ken Robinson underlines the need for young people to be taken on a journey of discovery for them to gain the most from cultural education:

> *'When people find their medium, they discover their real creative strengths and come into their own. Helping people to connect with their personal creative capacities is the surest way to release the best they have to offer.'* [12]

And the psychologist Mihaly Csikszentmihalyi agrees that creative achievements don't usually come about because of a moment of genius. Instead they are the result of a hard slog, of the dedicated learning of a craft:

> *'Most creative achievements are part of a long-term commitment to a domain of interest that starts somewhere in childhood, proceeds through schools, and continues in university, a research laboratory, an artist's studio, a writer's garret, or a business corporation.'* [13]

[12] Robinson, Ken, *Out of Our Minds: Learning to be Creative* (Chichester: Capstone, 2011)

[13] Csikszentmihalyi, Mihaly, *Creativity: The Psychology of Discovery and Invention* (New York: HarperCollins, 1996)

The author Malcolm Gladwell popularised this idea in his 2008 international bestseller *Outliers: The Story of Success.* Drawing on research by a Swedish academic, Gladwell talked about the so-called '10,000 Hour Rule', suggesting that to become a true expert in any skill often requires practising in the right way for a total of around 10,000 hours. In the area of cultural education subjects, the need to learn and discover through practice suggests that there is much merit to Gladwell's argument. All the more reason for ensuring that our young people are given the opportunity to start practising early, so that they can reap the benefits of their skills later in life. If they don't start this learning while they are at school, they will have little chance of catching up with their contemporaries from rapidly developing countries around the world where creativity and creative subjects are prioritised in the education systems. There is a risk of our nation becoming competitively disadvantaged if we fail to prioritise them here.

Cultural education subjects are sometimes dismissed as an easy option – suitable for the less gifted or able. This idea needs quashing straight away. Just as with every other facet of the education world, there is good cultural education and poor cultural education, but when taught well, subjects such as art and design, dance, drama and music are every bit as rigorous an intellectual challenge as any other subject in the school curriculum – and often they are also physically challenging. I believe unequivocally that young people should be able to study these subjects at GCSE and beyond. Any narrowing of the curriculum, or squeezing out of cultural

education subjects, at this point in a child's school career risks damaging the talent pipeline for our creative industries – diminishing the number of young people with the skills that business leaders in these industries constantly tell us they are seeking. The CBI's 2019 report on the UK's creative industries contained this warning:

> '*The fourth industrial revolution will transform the future of work and jobs with high levels of creativity are likely to be more resilient to automation. UK jobs in the creative industries are expected to grow by 5.3 per cent and double the average rate of employment, which will increase by 2.5 per cent. This means 119,495 new jobs for young people by 2024. And yet, there has been a rapid decline in the teaching of creative subjects in schools. Creativity must be considered equally important to numeracy and literacy in all schools.*' [14]

These are fast-growing industries, vital to the UK economy, and we should not ignore the CBI's message about the type of talent that UK plc requires to stay ahead of the international game. When he was Mayor of London, Boris Johnson made a similar argument around the importance of young people learning music in school. Back then, I chaired the Mayor's Music Education Taskforce, set up to help drive forward music education in London. Among its achievements was the publication in 2014 of the 'London Music Pledge' – a series of commitments around music education. Introducing the pledge, Boris Johnson wrote passionately on the subject

[14] https://www.cbi.org.uk/media/3857/12527_creative-industries_hyperlinks.pdf

– and why investing in music education made social and economic sense:

> 'The language of music, with its subtlety, depth and fascinating notation, is as rich as any spoken language on the planet. To reach the level of physical mastery that playing an instrument demands is as mind-boggling as the achievements of Pelé or the Williams sisters. And for a team of people to unite in making music – communicating with confidence, emotion and artistry to others – is one of the most powerful forms of community I can imagine . . . Music is important for our economy. London needs creative people and music is one of our most successful exports. The creative industries generate £21 billion for London's economy each year and hardly any music graduates are out of work. But music also has a bigger purpose, personally and socially. It's unique in challenging human beings to draw upon a huge range of intellectual skills and use them, in that moment, to turn the mundane into the beautiful – to create emotion.'[15]

Passing on the baton

As well as learning in the classroom, it's important for young people to be able to make a connection with the people who create the art and culture around them.

In my job, I am fortunate to talk to talented artists on a regular basis. I particularly remember meeting two especially inspiring writers on the same day, when I gave a speech at the

[15] 'London Music Pledge 2014', Greater London Authority (2014)

announcement of the new Waterstones Children's Laureate back in 2015. Before the new name was revealed, I joined with the chief executive of Waterstones, James Daunt, in thanking outgoing Children's Laureate, the wonderful Malorie Blackman. In her two years in the role, she worked tirelessly to encourage young people all over the country to share her love of reading, books and libraries.

I then watched as Malorie handed over the baton to the brilliant illustrator and writer Chris Riddell, who would go on to hold the title until the middle of 2017. He drew his way through his time as Children's Laureate, posting a daily doodle on his website, charting his adventures in schools, libraries and bookshops around the country. I can also remember seeing Lauren Child, creator of the much-loved Charlie and Lola, take over from Chris between 2017 and 2019. I was very taken by her passionate argument for 'the need for children to be allowed time to think and dream, and the space for ideas to collide and connect' and for her advocacy of the importance of high-quality illustrations in children's books. As you might expect, the current Children's Laureate, Cressida Cowell, is another believer in the influence of reading on young lives:

> *'Books are transformative because of their unique ability to develop three key magical powers: intelligence, creativity and, most important of all, empathy. Words are power; let's take magic seriously.'*[16]

[16] www.booktrust.org.uk/news-and-features/news/news-2019/cressida-cowell -announced-as-new-waterstones-childrens-laureate/

Malorie, Chris, Lauren and Cressida all possess a special magic of their own: an ability to light a spark of creativity inside the young people that they encounter. It's a big part of being Children's Laureate.

One of the most important responsibilities of the Arts Council is to nurture and inspire the next generation of creative talent in our schools and colleges. We need to build that next generation of audiences and creative practitioners, no matter what their background or where they live. Working with heroes like Malorie, Chris, Lauren and Cressida, who are so keen to share their personal creative talent with the next generation, makes the effort far more effective. The possibilities suddenly seem limitless – which is what creativity is all about.

Making new connections with young people isn't only the preserve of writers. Every year, over the Christmas period, I make sure that I see a handful of pantomimes around the country. The Marlowe Theatre in Canterbury's annual offering, written and directed by panto specialist Paul Hendy and produced by Emily Wood through their company Evolution Productions, is a particular favourite of mine – not least because Ben Roddy, who plays the dame each year, is to my mind among the best in the business.

❝ *As well as learning in the classroom, it's important for young people to be able to make a connection with the people who create the art and culture around them.* **❞**

I also try to catch the panto at the Customs House in South Shields, home of another great dame, Ray Spencer. He co-writes the pantomime each year with Graeme Thompson, the pro vice-chancellor at the nearby University of Sunderland. When he's not donning outrageous wigs and dresses, Ray is also the executive director of the Customs House. In 2019, I watched a daytime schools performance of *Snow White*, filled with primary-age children who were loving every moment of their theatrical experience. In previous years, I have been to evening performances and looking around the auditorium, I have seen people of all ages, and many multi-generational family groups. At the Customs House, there are also performances with sign language for D/deaf people and 'relaxed' performances, with gentler lighting and fewer loud noises, which are suitable for audiences with autism spectrum conditions, or who have other special needs. These tailored performances are now a common part of most pantomimes up and down the country, as are dedicated performances for schools.

So, here is an art form that is engaging on an equal level with people from all walks of life, young and old, with and without disabilities. As many as 3 million people a year enjoy pantomimes in theatres across the UK – making it among the most truly diverse artistic activities in the country. Importantly, pantos get young people from all backgrounds into theatres. These children become used to being in cultural spaces and watching acting, singing and dancing on a stage. For some of these youngsters, who come from tougher economic environments, a school trip to the pantomime might well be their first

visit to a place that has a stage and seats that tip up. It will certainly open their eyes to a different world – and it could quite possibly change their lives.

Pantomimes are often billed as being 'fun for all the family'. For me, having fun is a key part of helping us all to live happier lives. So, watching or listening to performances or visiting galleries, museums or libraries purely for the joy they bring to an individual or a family is an end in itself. But the work created by cultural organisations often gives us bonus benefits as well – not least in opening up the minds of young people. This has been evident to me on the two occasions I've visited Grimm & Co in Rotherham. This magical emporium brings creative writing alive for young people by helping them let their imaginations transport them to worlds far away from the streets of Rotherham – or the streets of any other part of England, for that matter. I defy anyone – young or old – to visit and not to be moved and excited by the sense of creative possibility throughout the building. Although there's a strong education message behind all of Grimm & Co's work, it's unashamedly focused on having fun.

In 2014, Arts Council England published 'Understanding the Value and Impacts of Cultural Experiences'. This report suggests that when people engage in a cultural activity – a pantomime performance, for example – the activity has three stages of impact. The first happens while the activity is actually going on. This is pretty obvious, given that the audience member will be watching and hearing something happen in front of them. The other two are less overt. Researchers have

observed the second stage in the hours and days after the artistic event, with effects including emotional and spiritual uplift and learning and critical reflection. The third stage can continue for weeks or even years after someone attends an arts event. The good news is that the benefits accrue over time. The more often people attend arts events, the bigger the cumulative impact of these events on their lives.[17]

Cultural education should start early in children's lives. We shouldn't be waiting for formal schooling to kick in before introducing playing music, dancing, acting, reading, writing, painting, drawing, building, making and creating into the lives of babies and toddlers. In her 2011 independent report for the government on early years provision, Dame Clare Tickell clearly lays out a rationale for delivering cultural education to the very youngest children:

'Alongside the three prime areas of personal, social and emotional development, communication and language, and physical development, I propose four specific areas in which prime skills are applied: literacy, mathematics, expressive arts and design, and understanding the world. Practitioners working with the youngest children should focus on the prime areas, but also recognise that the foundations of all areas of learning are laid from birth – for example, literacy in the very early sharing of books, and mathematics through early experiences of quantity and spatial relationships. Any focus on the prime areas will be

17 Carnwarth, John D. and Brown, Alan S., 'Understanding the Value and Impacts of Cultural Experiences', Arts Council England (2014)

*complemented and reinforced by learning in the specific areas,
for example expressive arts is a key route through which children
develop language and physical skills.'*[18]

Music offers fine examples of a number of generations coming together to enjoy a creative activity. Nowhere has this been more apparent to me than at the brass band concerts that I've attended. Sometimes there are three generations performing together onstage – each player with a mutual respect for the incredibly high standards of musicianship exhibited by all the other members of the band, no matter what their age. And the standards of musicianship in the English brass band tradition are extraordinarily high. Many of the concerts take the form of rigorously judged competitions, and playing in a brass band is a deadly serious business for those involved.

The Great Northern Brass Arts Festival at Manchester's Bridgewater Hall sticks in my mind. There were terrific performances by the likes of The Fairey Band, who hail from just down the road in Stockport, and the Brighouse and Rastrick Brass Band from across the Pennines in West Yorkshire. Alongside these adult bands were young performers from the National Children's Brass Band of Great Britain and a group from a single school in Rochdale – the Wardle Academy – whose playing was so tremendous that it almost lifted the roof off the Bridgewater Hall.

[18] Tickell, Clare, 'The Early Years: Foundations for Life, Health and Learning', Department for Education (2011)

I witnessed the same musical excellence at the National Youth Brass Band Championships in Warwick during the summer of 2019. This day-long event saw thirty brass bands from all over the country made up of players under the age of eighteen come together for a day of magnificent music. It was life-affirming to watch and hear.

If you ever have any doubt about the standards of musician-ship that can be reached by young people, then book a seat at the Music For Youth Schools Prom, which runs every November at London's Royal Albert Hall. The performances from right across the music spectrum – from classical to rock, choral to jazz, hip-hop to folk – are outstanding.

And if you have fundamental doubts about the way in which cultural education can change young lives, then look out for a performance by Liverpool's West Everton Children's Orchestra, which is based at Faith Primary School in one of England's most economically disadvantaged communities. The area is being transformed under the leadership of musicians and education specialists from the Royal Liverpool Philharmonic Orchestra.

The West Everton Children's Orchestra is one of six 'In Harmony' programmes in England funded by the Department for Education and the Arts Council. The others are run by the Music Education Hubs in Lambeth, Nottingham and Telford & Stoke, by the Sage Gateshead in the north-east and by Opera North in Leeds. Inspired by 'El Sistema' (the famous publicly funded music education

programme in Venezuela), the project inspires children and their families through music by encouraging the whole school (including the teachers and, in Faith Primary's case, the lollipop man) to form an orchestra. The results have been profound.

Since the programme began, there have been significant increases in children's educational attainment in reading and numeracy. And there have been improvements in self-esteem, confidence, pride and wellbeing. Not only are the children learning music for four and a half hours a week in curriculum time, but, when after-school activities are also taken into account, two thirds of them are spending as much as a total of ten hours a week learning music.

I've seen the West Everton Children's Orchestra performing both in their school and in front of a packed audience at Liverpool's Philharmonic Hall. The latter remains one of the most moving orchestral concerts I've witnessed – making the impact of the programme so much more obvious than any of the impressive statistics quoted above. You can see it in the concentration, dedication and discipline as the children perform. And then in the broad smiles on their faces as they take their bows to rapturous applause at the end of the concert. I'm not the only one with a soft spot for the programme. As the *Guardian*'s Tom Service wrote:

> 'I saw the government's "In Harmony" scheme in action in Liverpool and what an astonishing, inspiring experience it was ... seeing it in action is the sort of experience that

would make a music-educational evangelist of any politician.[19]

The dance education on offer in England is just as exciting as that in the world of music. Organisations such as The Place, home to the London Contemporary Dance School, are pioneering the provision of high-quality training to the next generation of dancers and choreographers. And I defy anyone to watch a performance by the Sadler's Wells-based National Youth Dance Company and not to be thrilled and energised by the onstage accomplishments of the teenage dancers from all over the country who come together annually to create and tour a major new dance piece. Each year they work with a different world-class guest artistic director. And their performances keep on getting better and better. A particular favourite of mine was the premiere of MADHEAD, choreographed by the Olivier Award-winning dance artist Botis Seva at DanceEast in Ipswich in April 2019. It went on to tour around the country to great critical acclaim.

And remember, cultural education helps achieve all this – and in the course of it, provides jobs in our fastest-growing sector. As Sir Damon Buffini, the chair of the National Theatre and a founding partner of the global investment company Permira, says:

[19] Service, Tom, 'Why the In Harmony project rings true', *Guardian* (30 September 2009)

'Cutting-edge creative industries are hungry for talent and ideas. Britain has both and it is in no small part due to our investment in the arts over the last half-century – in schools, in universities and through public funding for visual and performing arts.'[20]

There really are jobs out there for young people whose talent has been identified and nurtured. Some of the young people who take cultural education subjects at school will go on to study at specialist conservatoires or arts institutions such as the Royal Northern College of Music in Manchester, the Northern School of Contemporary Dance in Leeds or one of the specialist colleges that together make up the University of the Arts London, such as the London College of Communication, the London College of Fashion and Central Saint Martins.

Just take a look at this list of the top ten UK universities from where you're most likely to get a graduate job, along with their graduate employment rate:

1. Royal College of Music, London – 100%

2. Trinity Laban Conservatoire of Music and Dance – 99.1%

3. Royal Agricultural University, Cirencester – 98.2%

4. Bishop Grosseteste University, Lincoln – 98.1%

[20] 'How Public Investment in Arts Contributes to Growth in the Creative Industries', Creative Industries Federation (2015)

5. University of Buckingham – 98.1%

6. Royal Conservatoire of Scotland, Glasgow – 98%

7. Royal Northern College of Music, Manchester – 97.8%

8. Arts University Bournemouth – 97.4%

9. Courtauld Institute of Art, London – 97.3%

10. Robert Gordon University, Aberdeen – 97.2%[21]

Six of them are specialist arts institutions – proof again of the Learning Dividend we gain from investment in arts and culture, and investment in cultural education in particular. But these specialist institutions are not only important because they add to the talent pipeline, they also play a significant role in helping to frame the cultural world into which that talent emerges.

For too long, further education colleges have been an undervalued part of the education world. But I believe that they have a significant role to play in supplying the producers, technicians, craftspeople and artists who will drive forward the creative industries content explosion that we can expect over the coming years. These institutions teach the skills needed for roles across the creative industry, equipping students with the knowledge and experience required to compete in a highly competitive world.

21 Ali, Aftab, 'Exam Results 2015: Top 10 UK universities where you're most likely to get a graduate job from', *Independent* (18 August 2015)

Rather than being seen as less important than their higher education cousins, further education colleges should also be cherished for the significant role they play in smaller towns and rural communities – where they are often the only provider of education to people over the age of eighteen for miles around. They also offer a new chance to gain qualifications for young people who, for whatever reason, have not achieved as much as they might have done during their years at school. And they focus a lot of their teaching on developing skills that are needed in the world of work. Many students at further education colleges go straight into employment; others will go on to study at university – whichever pathway they choose, their success will be in no small part down to the opportunities offered to them by their local further education college.

The network of further education colleges across the country has the experience and the know-how to build the next generation of production and technical talent we require for our home-grown creative industries to flourish, and to attract the inward investment from multinational media and technology content creators, such as Netflix and Amazon, which are already building content creation hubs in the UK with the aim of serving global markets. These big companies need employees with specialist skills – and our further education colleges and specialist arts universities are key players in ensuring that this talent pipeline runs freely.

Although I believe that higher education institutions will play an increasingly important role as custodians and co-investors

in our creative and cultural institutions in the coming years, university is by no means the only route into a job in the creative industries. A renewed focus on apprenticeships is starting to make a difference across the arts and culture sector. On my travels, I have met a range of impressive young apprentices starting out on their careers in arts organisations, museums and libraries. I was struck by how well integrated into the day-to-day lives of their organisations the apprentices were, whether at the London Transport Museum, the Grundy Art Gallery in Blackpool or Hull Truck Theatre. Not only were they eagerly seizing the opportunity to learn about their chosen careers, but their organisations were benefiting from the specific insights that only a highly motivated, engaged teenager or twenty-something can bring.

Nurturing the new generation of talent

There's a lot of talent out there among young people – and the lucky ones are achieving great things with wonderful opportunities such as performing at the Schools Proms at the Royal Albert Hall. Others, like the children of West Everton, are being given equally wonderful opportunities to start their cultural education journeys closer to where they live. But we need to make sure that all of the young creative talent in

❝ *University is by no means the only route into a job in the creative industries. A renewed focus on apprenticeships is starting to make a difference across the arts and culture sector.* **❞**

England is getting the chance to achieve great things. It's only then that the Learning Dividend will pay out for all of our young people – and for society as a whole.

Often those parents who can afford to do so (and who realise the importance of cultural education) improve the opportunities for their children by making a series of interventions in their lives. This might include taking them to ballet or drama lessons; encouraging them to play a range of musical instruments until they find one that they enjoy; visiting the theatre, the cinema, galleries and museums; having a library card and reading books for pleasure; or buying them arts materials so that they can make their own creations. This is, of course, a good thing but it means that young people who come from tougher economic backgrounds, where discretionary spend is tight, and where there may be no family experience of engaging with arts or culture, are immediately at a huge disadvantage.

The Arts Council's Cultural Education Challenge is a national call to action designed to place the issue of cultural education on the public agenda and to help ensure that all children and young people right across the country are provided with a coherent cultural education. In defining the purpose of this call to action, the Arts Council identified nine key elements that should form part of every child's school life, highlighted in these three statements:

- *Every child should be able to **create**, to **compose** and to **perform** their own musical or artistic work.*

- *They should all be able to **visit**, to **experience** and to **participate** in extraordinary work.*

- *They should be able to **know** more, to **understand** more, and to **review** the experiences they've had.*

Arts Council England's Cultural Education Challenge seeks to bring together schools, higher and further education institutions, local authorities, central government, arts and heritage organisations, museums, libraries, charities, philanthropists and businesses in local areas so that they can share resources and create a series of Local Cultural Education Partnerships. At the time of writing at the beginning of 2020, 117 are operating across the country. More will follow, as the challenge rolls out to new places. We learned a lot about what could be achieved for the Learning Dividend from our first three pilot Local Cultural Education Partnerships, which were established in Bristol, Great Yarmouth and Barking and Dagenham. Already, we are seeing their successes mirrored in villages, towns and cities across the land.

Cultural education needs to be of a high quality and to be available to those who currently have the least opportunity to enjoy it. There is startling evidence that those from educationally deprived backgrounds are least likely to engage with cultural activities, perpetuating a cycle of exclusion. It's a national tragedy that those talented young individuals are failing to achieve their potential. So we need a sustained long-term investment in talent that exists, not in short governmental funding cycles, but for a generation. That way we

can know that a child born today can enjoy cultural education for the next twenty-five years of their life through to and beyond the end of their studies.

We also need to gather data to help us better understand what interventions make the most positive difference during this twenty-five-year period. In 2019, families with new-born babies in Leicester began to be recruited to a research project run by De Montfort University supported by Arts Council England dedicated to finding out about the benefits to babies and young children of being regularly involved in arts and creative activities. Called 'Talent 25', the programme will eventually recruit 400 babies (and their families) over a four-year period with the intention of following their cultural journey through the first twenty-five years of their lives. It's an ambitious project, but it will hopefully give us some real insights into how young people's lives are influenced by cultural and artistic activities. I'm looking forward to seeing the final report in the year 2044.

Powering the economy

I will discuss the economic benefits for investing in arts and culture in more depth in Chapter 6, when I come to think about the Enterprise Dividend. But it would be wrong to divorce our thinking about educational 'inputs' into a young person's life from their economic 'outputs' down the line, in adulthood. There is no doubt in my mind that another reason for making creativity central to our education system is that it encourages young people to be original. Certainly,

our business leaders want an education system that produces something different, because they know that innovation and imagination are superpowers that can supercharge a nation's economic destiny.

They want employees who are numerate, literate *and* creative. The American venture capitalist Scott Hartley describes those who specialise in the humanities or social sciences as 'fuzzies', and those who study computer or hard sciences as 'techies'. Contrary to many people's expectations, he argues that it is the former who drive forward the most creative and successful new business ideas.[22]

Once a principal ballerina at the Royal Ballet, following her elevation to the House of Lords in 2018, Deborah Bull is now more correctly known as Baroness Bull of Aldwych in the City of Westminster. She has taken the opportunity to speak regularly and eloquently on behalf of the arts during her time in the House. In her maiden speech, she argued that creativity was a key skill for young people looking to make their way in the world of work, whether they wanted to do a job that was artistic or scientific:

> *'Too often, creativity is seen as the preserve of artists – of people like me – but it is as important to the scientist or the engineer as it is to the musician and the dancer. The world's most pressing challenges will never be addressed by technology alone, but when*

22 Hartley, Scott, *The Fuzzie and the Techie: Why the Liberal Arts Will Rule the Digital World* (Boston: Houghton Mifflin Harcourt, 2017)

*creativity is employed to imagine how machines can best serve
human needs, the results can change the world.'* [23]

In the same year that Baroness Bull made her maiden speech,
Google's director of engineering Dr Damon Horowitz told
a conference that the company thought it as important to
hire arts and humanities graduates as those with business
and technology degrees.[24] And in his 2011 MacTaggart
Lecture in Edinburgh, Eric Schmidt, the executive chair-
man of Alphabet Inc. (the company that owns Google), was
critical of the UK for turning its back on the nurturing of its
polymaths.[25]

Tony Wagner, an academic based at Harvard University's
Innovation Lab, identifies 'Seven Survival Skills' that young
people need in the twenty-first century:

1. Critical thinking and problem-solving

2. Collaboration across networks and leading by influence

3. Agility and adaptability

4. Initiative and entrepreneurship

5. Accessing and analysing information

[23] https://www.theyworkforyou.com/lords/?id=2018-09-06c.1973.0

[24] https://www.timeshighereducation.com/news/google-leads-search-for
-humanities-phd-graduates/416190.article

[25] https://www.theguardian.com/media/interactive/2011/aug/26/eric-schmidt
-mactaggart-lecture-full-text

6. Effective oral and written communication

7. Curiosity and imagination[26]

Whole new industries are springing up that fuse together traditional creative skills with new digital technology. Let's take video games as an example. The UK has made a name for itself as a world leader in this field. There can be few better examples, if any, of an industry that requires employees with technical and digital knowledge to enable them to write computer code, but also to have the creative skills to develop narratives, design visuals and engage socially with video-game players. They need those seven skills identified by Tony Wagner. But, as Ukie, the trade body for the UK's games and interactive entertainment industry, led by Dr Jo Twist, pointed out in 2017, our education system is failing to fuel the required talent pipeline well enough or quickly enough.[27] And this isn't just about possessing computer coding skills, it's about being all-round creative beings.

The Learning Dividend for tomorrow

One of the big challenges of designing an education system for young people being born today is that we don't know exactly what the world will be like in a quarter of a century's time when they are making their way into the world of work.

26 Wagner, Tony, *The Global Achievement Gap: Why Even Our Best Schools Don't Teach the New Survival Skills Our Children Need – and What We Can Do About It* (New York: Basic Books, 2009)

27 Ukie, *Powering Up: Manifesto for unlocking growth in the games industry* (2017)

It's a fast-changing world out there, as I'll discuss in Chapter 4 when I talk about the Innovation Dividend, and we mustn't simply assume that the knowledge, skills and understanding that worked for those of us who were at school in the 1960s, 1970s and 1980s will be as beneficial for a child born in 2020. Since the turn of the millennium, the world has changed beyond recognition thanks to the adoption of new technology in every aspect of our day-to-day existence. Think how much an invention such as the iPhone has changed our lives. Yet, the first of these devices only went on sale on 29 June 2007. Today, it's hard to remember what life was like before their existence.

My message to everyone who cares about the education of our next generation is simple: creativity in education matters, and it pays dividends. It goes without saying that literacy and numeracy should be central pillars of every child's education, but so should creativity. By all means equip children with knowledge and skills and understanding across a wide range of subjects, but equip them most of all with the creativity to make the best use of their talents and to react to all that the brave new world can throw at them. Nurture their ability to imagine, to innovate, to build and to create. Give them the chance to invent tomorrow. When they're doing that, the Learning Dividend truly pays.

the feel-good dividend

in brief . . .

Scientific evidence shows that taking part in artistic and cultural activities can improve our health and wellbeing. Participating in arts and culture can make us feel happier, and can offer clear medical benefits in the treatment of a range of conditions. At a time when financial pressures on the National Health Service have never been greater, therapies involving arts activities and cultural venues offer a cost-effective alternative to drugs and other treatments. Indeed, in some cases, they have been proven to be more medically effective. The benefits provided by the arts and health sphere are particularly notable both in the lives of teenagers and older people.

Happiness as a policy

The economist Richard Layard distils a lifetime of wisdom, learning and insight gained during his long career at London School of Economics into his brilliant book *Can We Be Happier?*[1] which was published at the beginning of 2020. Layard argues that everyone who is responsible for developing public policy – whether they be elected politicians, civil servants, or policy researchers – should have the happiness of the population at large as their primary goal.

For me, it is a compelling argument. After all, surely there can be no better reason for making a decision to invest public money in something than people's lives being demonstrably improved by that choice. I believe that the decisions we make every day at Arts Council England to invest in artists, arts organisations, museums and libraries can absolutely be defined in terms of the myriad ways they improve people's lives, the places they live, and how they feel about themselves, their environment and the possibilities for their future. When we get it right, their lives are made better. Their sense of wellbeing increases. They have the opportunity to flourish. In short, those decisions we make help them to be happy.

Some people do worry about the word 'happy'. They see it as perhaps being a bit amorphous, or maybe a little too idealistic. Many of the critics of happiness as a goal of public

[1] Layard, Richard, *Can We Be Happier? Evidence and Ethics* (London: Pelican, 2020)

policy are also critical of the idea that kindness should be a factor in how public bodies behave. I will come on to discuss kindness a little later in this chapter. But, for me, happiness and kindness are at the very heart of lives that are well lived. And for that reason, they should be central to public policy-making, both as an end goal and as values we embody along the way.

In 2019, New Zealand became one of the first countries to place greater importance on the wellbeing of its citizens than the more usual measures of economic success when it came to setting the nation's budget. It followed a speech to the United Nations in 2018, by New Zealand's Prime Minister, Jacinda Ardern, in which she promised that her country would be a place where 'success is measured not only by the nation's GDP but by better lives lived by its people'. In Britain, we were the first country to measure national subjective wellbeing as an official statistic. The former Cabinet Secretary, Lord Gus O'Donnell, is a big supporter of subjective wellbeing as a goal of government policy. After leaving the Civil Service and moving to the House of

" *Happiness and kindness are at the very heart of lives that are well lived. And for that reason, they should be central to public policy-making, both as an end goal and as values we embody along the way.* "

Lords, he chaired a commission into how this might best be achieved.[2]

My interest in happiness has introduced me to the world of positive psychology. As I mentioned in the introduction, over the past few years I've been on my own personal learning journey studying applied positive psychology at Bucks New University and coaching and behavioural change at Henley Business School. The more I have delved into the academic research, the more convinced I have become that the over-arching goal of public policy should be to increase happiness. There will of course be other aims, some highly pragmatic, some more ideological. But, in the end, none of them are quite as meaningful as enabling people to live happier lives.

The leading American psychologist Martin Seligman, who's based at the University of Pennsylvania, reset the thinking around psychology at the turn of the millennium by arguing that psychologists had focused a lot of time and effort on reducing the negative factors in our lives – but relatively little research and thinking had gone into what made people's lives better. He became one of the founding fathers of positive psychology – which is often defined as the science of what makes life worth living.

2 O'Donnell, G., Deaton, A., Durand, M., Halpern, D. and Layard, R., *Wellbeing and Policy* (London: Legatum Institute 2014)

And there is plenty of science out there to back it up. Alongside Seligman's groundbreaking book *Authentic Happiness*,[3] Sonja Lyubomirsky, a professor at the University of California, has penned *The How of Happiness*[4] which might read to some a little like a self-help manual, but is in fact rooted throughout in peer-reviewed scientific research and clinical trials. The same is true for the book *Positivity*[5] by Barbara Fredrickson, a professor at the University of North Carolina, much of whose research centres on optimism. All of her work is based on huge data sets – the evidence is there.

This really isn't fanciful New Age woo-woo. It can make a massive difference to people's lives. For that reason, my third Arts Dividend centres around helping people to live better, healthier lives and feel happier as a result. It's most closely related to the Creativity and Learning Dividends described in Chapters 1 and 2 in that it directly relates to people rather than places or organisations. But it's a separate development onwards from these two dividends and deserves to be high-lighted in its own right.

[3] Seligman, Martin, *Authentic Happiness: Using the New Positive Psychology to Realize Your Potential for Lasting Fulfillment* (London: Nicholas Brealey Publishing, 2002)

[4] Lyubomirsky, Sonja, *The How of Happiness: A Practical Guide to Getting the Life You Want* (London: Sphere, 2007)

[5] Fredrickson, Barbara, *Positivity: Groundbreaking Research to Release Your Inner Optimist and Thrive* (New York: Crown Publishers, 2009)

The Feel-Good Dividend comes about when investment in art and culture results in improvements to our health and wellbeing, enabling us to flourish more than we would otherwise do. Sometimes these improvements can be quite specific – and distinctly medical in their nature – relating to a particular mental or physical health condition. On other occasions, the benefits of participating in artistic and cultural activities, either as a creator or as an audience member, are less health-specific and more about our general wellbeing. Culture Minister Caroline Dinenage points out that the value of the cultural sector's 'contribution to our mental and physical wellbeing is well documented, and it's hugely important for old and young alike'.[6]

The relationship between the arts and health is growing fast – as is the scientific data to show what works most effectively. Dr Daisy Fancourt from University College London is one of the leading researchers in this area. I could use up all of the pages left in this book listing academic research that shows how cultural activities directly benefit our health and wellbeing. But I don't have to because it's something that Fancourt has actually done in a report she co-authored with another UCL researcher Saoirse Finn in 2019 for the World Health Organisation.[7] The report details scientific research showing how the arts can prevent people from developing illnesses, can promote healthier lifestyles and can be used

[6] www.unesco.org.uk/wp-content/uploads/2020/04/UNESCO-Conference-on-Covid19-MDC-speech-22-april.pdf

[7] Fancourt, Daisy and Finn, Saoirse, *What is the evidence on the role of the arts in improving health and well-being?* (World Health Organisation, 2019)

directly to treat and manage some illnesses. Fancourt and Finn provide a handy summary of what we can learn from this research under the headings 'Prevention and Promotion' and 'Management and Treatment':

Prevention and Promotion

The arts can:

- *Affect the social determinants of health (e.g. developing social cohesion and reducing social inequalities and inequities);*

- *Support child development (e.g. enhancing mother–infant bonding and supporting speech and language acquisition);*

- *Encourage health-promoting behaviours (e.g. through promoting healthy living or encouraging engagement with healthcare);*

- *Help to prevent ill health (including enhancing wellbeing and reducing the impact of trauma or the risk of cognitive decline); and*

- *Support caregiving (including enhancing understanding of health and improving clinical skills).*

❝ *The Feel-Good Dividend comes about when investment in art and culture results in improvements to our health and wellbeing, enabling us to flourish more than we would otherwise do.* ❞

Management and Treatment

The arts can:

- *Help people experiencing mental illness at all stages of the life-course (e.g. by supporting recovery from perinatal mental illness and after trauma and abuse);*

- *Support care for people with acute conditions (e.g. by improving the experience of and outcomes in care for hospital inpatients and individuals in intensive care);*

- *Support people with neurological disorders (including autism, cerebral palsy, stroke, degenerative neurological disorders and dementias);*

- *Assist in the treatment of noncommunicable diseases (including cancer, lung disease, diabetes and cardiovascular diseases); and*

- *Support end-of-life care (including palliative care and bereavement).*[8]

In total, Fancourt and Finn's report lists no fewer than 962 separate research studies in this area. And new research is taking place all the time. So, in the months between the WHO report being published and me writing this book, there has no doubt been a wealth of fresh scientific data generated in this fast-growing area. Each new report further cements the case for an increase in focus on direct investment in the arts to improve our national health and wellbeing. Often,

8 Ibid.

artistic or cultural interventions are more effective than a pill, cheaper for the NHS, stop people getting ill in the first place – and have far fewer harmful side-effects.

We know that being around creativity in general – encountering a performance; seeing or hearing art and culture; taking part in a cultural activity – can make us feel happy and relaxed. With the hectic lives we lead in twenty-first-century Britain, happiness and relaxation are often hard to come by, so anything that can help to address this has to be a bonus. Arts Council England research has ranked cultural activities and wellbeing:

All arts and culture activities are significantly associated with happiness and relaxation after controlling for a range of other factors. The ranking of cultural activities in terms of positive effects on happiness is as follows:

1. *Theatre, dance, concerts*

2. *Singing, performing*

3. *Exhibitions, museums, libraries*

4. *Hobbies, arts, crafts*

5. *Listening to music*

6. *Reading*

The ranking of cultural activities in terms of positive effects on feeling relaxed is as follows:

1. *Exhibitions, museums, libraries*

2. *Hobbies, arts, crafts*

3. *Theatre, dance, concerts*

4. *Singing, performing*

5. *Reading*

6. *Listening to music*[9]

The Culture, Health and Wellbeing Alliance (formerly the National Alliance for Arts, Health and Wellbeing) identifies five main areas of arts in health. The first is about the introduction of arts into the healthcare environment. The second is about actually taking part in the arts through participatory programmes that enable patients to be creative themselves. The third centres on medical training, with many doctors now undertaking programmes that teach them about arts and health practice in their early years at medical school. The fourth is the use of arts therapy via registered therapists, which tends to take in drama, music and the visual arts as a means of working with a patient on a one-to-one basis. Music therapy is perhaps the most widely understood area of this work. I've seen some truly moving examples of it being used by charities such as Nordoff Robbins to connect with young people with profound and multiple learning disabilities. Professor Helen Odell-Miller and the excellent team at Anglia Ruskin University's music department in Cambridge

[9] Fujiwara, Daniel and MacKerron, George, 'Cultural Activities, Artforms and Wellbeing', Arts Council England (2015)

are leading the way in publishing groundbreaking research into the value of music therapy in effectively tackling a range of health-related challenges.

The fifth area is called 'arts on prescription', whereby medical practitioners prescribe arts and creative activities for patients. This is becoming particularly widespread for people with mental health illnesses and those suffering from social isolation. Often a programme of arts and cultural activities is prescribed alongside other medical interventions.[10] A fascinating research project led by Professor Helen Chatterjee and Professor Paul Camic at University College London looked at the value of 'Museums on Prescription'. This is based on what's known as 'social prescribing', which links people to sources of community support to improve their health and wellbeing. The project connected lonely older people at risk of social isolation to partner museums in London and Kent.[11]

This relatively new body of credible academic research on the ability of art and culture to improve our health and wellbeing means that the topic has started to become a more important sphere of interest for those who make public policy worldwide. Countries such as the UK, Australia, Canada, Norway, Sweden and the USA have all published significant reports on the subject in recent years. Arts Council England's 'The

10 http://www.artshealthandwellbeing.org.uk

11 https://www.ucl.ac.uk/museums/research/museumsonprescription

Value of Arts and Culture to People and Society' (2014) cites
a report by the Scottish Government that showed:

> 'Those who had attended a cultural place or event in the pre-
> vious twelve months were almost 60 per cent more likely to
> report good health compared to those who had not, and theatre-
> goers were almost 25 per cent more likely to report good health.
> Participation in a creative or cultural activity shows similar
> benefits: those who had done this were 38 per cent more likely
> to report good health compared to those who did not, but that
> figure rises to 62 per cent for those who participate in dance.
> Those who read for pleasure were also 33 per cent more likely to
> report good health. The findings are consistent with a growing
> body of population level studies on the impact of engagement in
> culture on key quality of life measures.' [12]

There is growing acknowledgement that there is a health
benefit to the arts. In 2013, the Royal Society for Public
Health identified a series of benefits from bringing visual, per-
formance and participatory arts into hospitals. They included:

> 'Decreased stress levels; decreases in anxiety and depression;
> improvements in clinical indicators such as blood pressure;
> decreased perception of pain; reduced drug consumption and
> reduced length of stay.
>
> In particular, music interventions in hospitals are showing
> increasingly strong evidence of beneficial effect on physical and

[12] 'The Value of Arts and Culture to People and Society', Arts Council England (2014)

psychological patient outcomes. In primary care, an early use of arts and health activity was in social prescribing schemes, and this remains the basis for many interventions, particularly in the field of mental health.' [13]

The idea of GPs prescribing arts activities as an alternative to drugs or other therapies is certainly catching on. If you look just inside the front door of Liverpool's magnificent Central Library, for example, you will find a row of shelves of 'Books on Prescription', which doctors recommend to patients as part of their treatment. The Reading Agency's 'Reading Well – Books on Prescription' programme now operates with great success in more than 99 per cent of English libraries. The latest data published in 2018 suggests that 83 per cent of participants who experienced mental ill health felt better able to understand their conditions, and 68 per cent felt that their symptoms had improved. [14]

It's an area that the Secretary of State for Health and Social Care, Matt Hancock, has prioritised since he took up the job in 2018. As a former Secretary of State for Digital, Culture, Media and Sport, he has seen with his own eyes the success of bringing cultural practitioners and healthcare practitioners together for the benefit of patients. He launched a new National Academy for Social Prescribing at the end of 2019. Chaired by Professor Helen Stokes-Lampard, it aims to grow

[13] 'Arts, Health and Wellbeing Beyond the Millennium: How Far Have We Come in 15 Years?' Royal Society for Public Health (2013)

[14] https://readingagency.org.uk/adults/impact/reading-well-books-on-prescription -evaluation-201819.html

this area of health practice by bringing providers together, developing best practice, and training healthcare and arts professionals.

All of this comes at a time when there is sustained pressure on NHS budgets and wide acknowledgement that preventative healthcare is often a far more economically efficient use of health funding than waiting to pay out to treat a condition once it has taken hold of a patient. It does therefore seem possible that arts-and-culture-related therapies could become a growing part of the healthcare on offer in this country. We now need to build on the existing excellent research to continue to prove the value of investment in this area of healthcare and the dividends returned on that investment.

Arts and older people

Although arts and culture have health and wellbeing benefits for people of all ages, it is worth pausing to underline the particular dividends for older people. An Arts Council England survey of people aged over sixty-five, undertaken by ComRes, showed that 76 per cent of older people said that arts and culture are important contributors to their happiness. And 60 per cent of those questioned said that arts and culture are important to making them feel healthy.[15]

I always enjoy visiting the University of Manchester's stunning Whitworth Gallery, which – with its collections of fine

[15] http://www.comres.co.uk/polls/arts-council-england-older-people-poll/

art, contemporary art, textiles, prints, wallpaper and sculptures – must rank among the finest galleries in the world. On my first visit there back in 2015, I was shown around by its then-director Maria Balshaw, who has since taken up the top job at Tate in London. The Whitworth had just reopened, fresh from a £15-million refurbishment.

While I marvelled at much of the art on show in this magnificent building, it is the memory of a small exhibition downstairs that has stayed freshest in my mind. As part of the Whitworth's Age Friendly programme, a group of older men had curated a selection of objects from the Whitworth's collection, which were displayed alongside other items related to their lives. It was part of a sustained programme by the Whitworth to engage more meaningfully with men in their sixties and seventies, who were under-represented among the gallery's visitors. Their exhibition told a fascinating story.

The Whitworth's head of learning and engagement, Ed Watts, became interested in researching older men's participation in cultural activities after noticing their relative absence from the gallery, in contrast with people of other ages. Funded by the Baring Foundation, his findings have been published as *A Handbook for Engagement with Older Men*. This useful little book offers insights to other cultural organisations wanting to encourage this group into their institutions, giving details of similar programmes in Glasgow, Rhyl, London, Gateshead and Belfast. The Baring Foundation has been a key investor in the area of creative aging – not least in the Celebrating Age partnership with all four of the UK's arts

councils, which has seen a series of research and delivery projects helping to improve the lives of older people through engagement with cultural activities.[16]

The medical world is becoming more aware of the possibilities of what can be achieved through art and culture in older people's lives. Guidance from the National Institute for Health and Care Excellence (NICE) published at the end of 2015 recommends that the NHS should provide opportunities for older people to engage in creative group activities, including singing and arts and crafts. NICE says that these sorts of activities support independence and mental wellbeing.[17]

The Mental Health Foundation has also published a report showing that activities such as storytelling and visual arts have a positive benefit on the overall health of the people who took part in terms of their mental health, while more physical activities such as drama and dance helped improve physical health.[18]

In 2011, perhaps spurred on by the stratospheric success of the BBC's *Strictly Come Dancing*, Bupa published a report that borrowed the programme's catchphrase 'keep dancing' as its title.[19] In the same year, Trinity Laban Conservatoire

16 https://cdn.baringfoundation.org.uk/wp-content/uploads/KCBaringReport_A4 _2019_ForWeb.pdf

17 http://www.nice.org.uk/guidance/ng32

18 'An Evidence Review of the Impact of Participatory Arts on Older People', Mental Health Foundation (2011)

19 'Keep Dancing: The Health and Wellbeing Benefits of Dance for Older People', Bupa (2011)

of Music and Dance published 'Dancing Towards Wellbeing in the Third Age'.[20] Both reports underline the benefits that dancing can have on older people's lives, with positive impacts reported for people suffering from arthritis, Parkinson's, dementia and depression. The Bupa report also highlights evidence that regular dancing has a relationship with preventing falls in older people because it can improve their body strength and balance. To younger readers, the risk of falling over may seem trivial, but it's a growing issue for gerontologists the world over. In his book *Being Mortal: Illness, Medicine and What Matters in the End*, Atul Gawande notes that every year 350,000 Americans fall and break a hip. Of these, 40 per cent end up in a nursing home and 20 per cent are never able to walk again.[21] Providing large-scale solutions that improve the lives of patients and reduce the financial costs to health services is a priority.

It's not only dancing that has a positive effect on people's lives. Research published by the Sidney De Haan Centre for Arts and Health at Canterbury Christ Church University showed that singing improves people's mental health and wellbeing, including reducing anxiety, stress and depression.[22]

[20] 'Dancing Towards Well-being in the Third Age: Literature Review on the Impact of Dance on Health and Well-being Among Older People', Trinity Laban Conservatoire of Music and Dance (2011)

[21] Gawande, Atul, *Being Mortal: Illness, Medicine and What Matters in the End* (London: Profile Books, 2014)

[22] https://www.canterbury.ac.uk/news-centre/press-releases/2015/research-shows-singing-improves-mental-health-and-wellbeing.aspx

Professor Stephen Clift led the study into four community singing groups, which were established across West Kent and Medway, in Chatham, Dartford, Maidstone and Sevenoaks:

> *'The participants reaped the same positive benefits of social interaction and peer support offered through the singing groups, which helped to clinically improve their mental health conditions. Some of the benefits experienced by the participants included an increase in self-worth and self-confidence, a reduction in stress, an improvement in memory and concentration and a sense of inclusion.'*

The musicians of the Bournemouth Symphony Orchestra are among the most widely travelled of any in the country, with a 'home patch' that stretches from Cornwall all the way along the south coast to Hampshire. They worked with researchers from Bournemouth University in a programme designed to study the power of music to provide support and therapeutic relief to people living with dementia, and to their carers. In a series of workshops, patients and carers played music together alongside the orchestra's musicians, while the academic researchers monitored the effects. The professionals

❝ *Regular dancing has a relationship with preventing falls in older people because it can improve their body strength and balance ... singing improves people's mental health and wellbeing, including reducing anxiety, stress and depression.* ❞

taught the participants to play along; nobody was left out, no matter their level of musical skill. After ten weeks of workshops, everyone who took part in the programme gave a concert performance, which was by all accounts a very moving experience.

Professor Anthea Innes, who was director of the Bournemouth University Dementia Institute at the time of the programme, said it had positive outcomes for all the participants:

'Social inclusion and a sense of community was an important, but unexpected outcome for everyone that took part. Progression with musical learning was clear for some of the people with dementia, and this gave them a sense of achievement and increased their confidence. Carers also felt happier as a result of attending the sessions, which provided them with respite. They also reported improvements in their relationship with the person with dementia. Coming to the group gave them something to talk about and look forward to.'[23]

The pioneering work developing dementia-friendly performances by the artistic team at Leeds Playhouse has proved to be so successful that the model has now been adopted by other theatres across the country, while museums and libraries offer rich resources for benefiting people living with dementia and their carers. With the prediction of increasing levels of dementia as our population ages over the coming

[23] White, Harry T., 'Breakthroughs in Bournemouth: how the BSO is providing relief for people with dementia', *Guardian* (22 June 2015)

years, this is a field where the art and culture community has much to offer society as a whole.

Art in hospitals

On the days when I'm working in the Arts Council's London office, I walk from St Pancras International railway station along the Euston Road, past University College Hospital. Opened by the Queen in 2005, the building still looks relatively shiny and new. It might not be the most obvious place to find art and culture, but look through the windows and you will see a treasure trove of artworks hanging on the walls of the corridors. Now, I don't like hospitals at the best of times, but the presence of art always makes the building seem far less foreboding and clinical to me. On more than one occasion, I've stopped to look more closely through the window at a particularly enticing picture.

University College Hospital has its own curator, Guy Noble, who is responsible for managing the hospital's art collection. He also curates exhibitions, oversees music performances in the hospital and arranges artistic activities in which patients can take part. It's all paid for by charitable donations, or by artists loaning work to the hospital on a temporary basis. Sometimes Guy is able to commission new art and his tastes are ambitious, with works by the likes of Sir Peter Blake, Grayson Perry and Stuart Haygarth hanging on the hospital walls. He believes that art is an important part of life at University College Hospital:

'There is a growing body of evidence around the clinical bene-
fits of arts on both staff and patients within healthcare settings.
However, in my experience it is the personal interactions and
conversations which I encounter on a daily basis that convince
me of the importance of arts in hospitals. For instance, a father
telephoned me about the pleasure he and his sick son took from
the hospital's exhibition programme. The changing displays
provided him with a reason to wheel his son from his bed to talk
and share stories whilst looking at the pictures. These cherished
trips to the hospital gallery helped them through some difficult
times. I was also fortunate to witness a non-responsive patient
suddenly smile as a result of a harpist playing by her bedside.
This simple emotion brought tears to all those around her. Such
anecdotes are not quantifiable within a medical sense but they
do reveal how the arts can bring comfort in the most difficult of
times and demonstrate how the arts can reach where medicine
sometimes cannot.'

Arts and kindness

One of the more intriguing conversations about art and cul-
ture I've enjoyed in the past few years was with Tina Corri
and Tom Andrews, who work with the arts charity People
United. I caught up with them, along with social psychology
professor Dominic Abrams, in People United's small office
on the University of Kent's campus in Canterbury.

The central thesis of People United involves thinking beyond
the more generally understood ways in which arts and culture
can have a positive effect on our health and wellbeing. Tom,

Tina and Dominic told me how they have been exploring the role that arts and creativity can play in bringing about a more caring society. In short, People United believes that the arts can promote kindness, and improve the world around us:

> *'In order for us to live well together in our increasingly intercon-nected and complex world we need to strengthen our capacity for empathy, compassion, friendship, social connection and concern for others, including future generations. Our defin-ition of kindness is rooted in theories of "prosocial behaviour"; where altruism is "a motivational state with the ultimate goal of increasing another's welfare", and prosocial behaviour, is "an action that helps or benefits another person."'* [24]

They don't see 'kindness' as a wishy-washy word, instead describing it as 'muscular'. People United's argument is that kindness can grow through the arts via four themes (or 'mediators', to use the correct psychological term):

> **Emotions** – *the arts can engage people's emotions directly and powerfully and in doing so can spark feelings, such as empathy, that are key for influencing kindness.*

> **Connections** – *arts experiences can bring people together and have the potential to create immediate strong connections between individuals and groups.*

[24] Broadwood, J., Bunting, C., Andrews, T., Abrams, D. and Van de Vyver, J., 'Arts and Kindness', People United (2012)

Learning – *the arts can create opportunities for people to learn from and about each other and the world.*

Values – *many arts experiences involve a deep exploration of human values which are key to determining how people live together and behave towards each other.* [25]

It's an attractive manifesto for social change through the arts. As well as conducting research, People United places artists in communities to put their thinking into action. This has included site-specific music and drama performances, interactive art installations, films, poetry and projects based wholly in schools. They describe their commissions as 'illuminating art and kindness through the creation of new participatory work'.

People United's thinking is echoed by my former boss at Arts Council England, Sir Peter Bazalgette, who now chairs ITV. His 2017 book *The Empathy Instinct: How to Create a More Civil Society* sets out a compelling manifesto for empathy across education, healthcare, the justice system, social cohesion and the introduction of new technology into our lives. He argues that the arts have a central role in delivering his 'Charter for Empathy'. To my mind, it's unquestionable that greater levels of altruism, tolerance, neighbourliness, concern for others and trust would make the world a better place. It's another dividend that investment in art and culture can pay out to society as a whole.

[25] Ibid.

the innovation dividend

in brief . . .

New technology has changed the way in which many industries operate. The arts and culture world is no different. Technology enables us to create, distribute and market cultural products and services in new and exciting ways, many of which have yet to be imagined. Many artists and cultural organisations have already embraced technological advances, connecting with the audiences of today and tomorrow, for whom digital content and devices are already a central part of life. Public investment in this area helps to ensure that our artists, curators and librarians have access to the latest software and hardware – and are trained in the skills to make the most of it. That way, arts organisations, museums and libraries won't get left behind the commercial entertainment businesses that compete for audiences' attention.

Digital disruption

When he was interviewed by Jeremy Paxman for the BBC's *Newsnight* in 1999, David Bowie made a prediction about the power of the internet. At the time, most commentators had not cottoned on to the potential of the World Wide Web, but Bowie foresaw that it would become the defining medium of the early part of the twenty-first century:

> '*The internet now carries the flag of being subversive and possibly rebellious and chaotic . . . I embrace the idea that there is a new demystification process going on between the artist and the audience . . . I don't think we've even seen the tip of the iceberg. I think the potential of what the internet is going to do to society – both good and bad – is unimaginable . . . The state of content is going to be so different to anything that we can really envisage at the moment where the interplay between the user and the provider are so in simpatico that it's going to crash our ideas about what mediums are all about.*'[1]

Bowie's prediction was remarkably accurate. As an artist, he understood and was able to articulate the creative possibilities that the internet offered him. Far from being rooted in traditional models for engaging with his audience and for creating and distributing his content, he embraced this uncharted territory.

Although I cannot claim to have any of David Bowie's technological foresight, I've always been a sucker for new gizmos

[1] https://www.youtube.com/watch?v=FiK7s_0tGsg

and gadgets, particularly those made by Apple. Some might say that this is just evidence of rampant consumerism on my part or some sort of desire for technological one-upmanship deep in my psyche, but I genuinely believe that Apple products have changed the way that I work for the better. They've made many aspects of my life more efficient, more effective, more fun and more environmentally sound.

The first-generation iPad only came into being in April 2010, yet its effect has been huge on users, both in the work and leisure parts of their lives. People in their early twenties have now had this sort of technology in their hands throughout their adult lives. Their mobile phone or tablet is their most important means of connection, and in an age of instant gratification, pretty much every sort of artistic and cultural content with which they might want to engage is only a few clicks away.

This provides a huge opportunity for the arts and culture world – but it's a major challenge too. Digital pioneers talk about the power of technology to disrupt existing worlds. I was particularly taken by a slide from an IBM presentation, which read:

The Digital Disruption Has Already Happened

- *World's largest taxi company owns no taxis (Uber)*

- *Largest accommodation provider owns no real estate (Airbnb)*

- *Largest phone companies own no telco infra (Skype, WeChat)*

- *World's most valuable retailer has no inventory (Alibaba)*

- *Most popular media owner creates no content (Facebook)*

- *Fastest growing banks have no actual money (SocietyOne)*

- *World's largest movie house owns no cinemas (Netflix)*

- *Largest software vendors don't write the apps (Apple and Google)*[2]

Entire sectors of the business world have already been disrupted by advances in digital technology and there is no reason to believe that those of us in the arts and culture sphere will be immune. We already have plenty of evidence for the huge changes that first digital downloading and then digital streaming have brought to the record industry, for example, and other art forms will not remain exempt from change.

The publishing industry has had to adapt to a world where digital books exist alongside printed editions and we are now seeing a huge growth in audiobooks thanks to the popularity of Amazon's Audible service.

Just a few years ago, speech-based audio content in the UK tended to be the preserve of listeners to BBC Radios 4 and 5 Live and commercial stations LBC and TalkSport. Now,

2 http://vrworld.com/2015/11/09/ibm-disruption-has-already-happened/

however, a whole new generation of listeners have discovered the joy of listening to the spoken word – often on headphones connected to their mobiles – with a proliferation of podcasts on just about any topic you can imagine.

Often when I am sitting on trains, I hear people in their teens and twenties having animated discussions about podcasts with an editorial focus on their favourite topics, whether that's sport, comedy, music or celebrity-led interviews. When I worked in radio in the 1990s, the idea of this age group listening in such large numbers to what are essentially speech-based radio programmes would have seemed highly unlikely. To be honest, traditional radio broadcasters were not making that much speech content aimed at this age group, and nor did they have the means of distributing the content even if they had been. All that was available back then was FM and AM radio licences, with DAB just starting out. Content distribution at that time was all about having a single linear feed from the broadcaster that was consumed by a mass of listeners at the same time. New technology, such as smartphones, Wi-Fi and 4G data plans, has changed all that, as has the ability for us as listeners to choose content that zooms in on our own particular area of interest. The mixture of new distribution channels and more content being produced by a wider range of individuals and organisations has seen huge growth for podcasts on online aggregators such as Spotify, iTunes, BBC Sounds and Global Player.

You don't have to be in the podcast business to learn from the patterns of behaviour we're seeing from consumers here.

Responding in the right way to this sort of change is all about seizing the chance to embrace new technology that allows us to invent previously unimagined creative entities. It's about how the people in charge of arts organisations, museums and libraries harness technology so that they operate more efficient and effective cultural businesses – for example, by sharing and using data to improve the way we communicate with audiences. And it's about how they directly connect great art and culture to the end consumers – whether they're listeners, viewers, readers or participants. They're doing this in an increasingly noisy and crowded world, where arts and culture organisations jostle for attention with myriad other products and services.

It's by getting this right that we bring the Innovation Dividend into play. And I should stress right now that I don't view the disruption as being negative. Rather, it is a force for creative possibility. The Warwick Commission on the Future of Cultural Value acknowledged the effect that technological innovation is having on arts and culture in this country:

'The digital revolution is transforming culture, just as it is transforming other aspects of our lives. It has increased levels of participation in informal cultural and creative activities, created new networks and forms of interaction, transformed the production and distribution of established art forms and allowed new art forms to emerge.'[3]

[3] Warwick Commission on the Future of Cultural Value, 'Enriching Britain: Culture, Creativity and Growth', University of Warwick (2015)

When art and tech join together

It's easy to dismiss technology companies as being a million miles removed from traditional cultural organisations, such as museums, galleries, libraries, theatres, or music venues. But for technology entrepreneur Baroness Martha Lane Fox, the connection between the two is clear:

> *'People don't always recognise the link between the technology sector and the UK's public arts. But to be a great coder you need to be as creative as a poet or designer. It is precisely this parallel which has encouraged me to not only advocate for the technology sector, including coding in schools, but to work with the Design Council and the Women's Prize for Fiction, advocating for creativity across the board. When we inspire each other we end up with a stronger society as well as a stronger economy, and having public organisations is an important part of that puzzle.'* [4]

In the spring of 2017, I was lucky to visit Austin, Texas for the SXSW festival (written as an acronym but spoken as 'South By Southwest'). This amazing international celebration of creativity is a showcase for innovation and imagination. It completely takes over the city for a couple of weeks. Bold, new, creative, imaginative ideas seem to pour out of every doorway of every building. Every inch of available space is used for performances or exhibitions of one sort or another.

[4] 'How Public Investment in Arts Contributes to Growth in the Creative Industries', Creative Industries Federation (2015)

Although the festival centres on film and music, many other art forms are in evidence and a huge conference and exhibition programme takes place alongside the performances.

It was a chance for me to see for myself how giants like Sony were using cutting-edge technology to create new entertainment concepts which could be just as relevant to the theatre practitioners of tomorrow as they are to the video-game players of today. Many of the big thinkers in the psychology of creativity and innovation gave lectures and masterclasses, alongside producers and people involved in the business of entertainment. And, of course, there were some fantastic performances too. On the flight home, I was galvanised by a feeling of optimism about the possibilities of how technology could be harnessed both to create new works of art and even art forms – and also how technological developments would continue to provide whole new platforms for creatives to connect with audiences.

When technology and the arts come together, there always seems to be a real spark of extra creativity. It's as if the two feed off each other to amplify an initial idea. Around the country, I've been introduced to some of the many arts and tech innovation hubs that are springing up.

In Nottingham, Broadway Cinema is home to Near Now, a producing, commissioning and artist development programme, which 'works closely with artists and designers to produce and present playful projects that explore technology in everyday life'. Artists use many of the disciplines that are

more familiar to the technology world to develop new creative ideas, solutions and processes.

Meanwhile, Pervasive Media Studios based at Watershed in Bristol hosts a community of artists, creative companies, technologists and academics exploring experience design and creative technology. Projects emanating from this collaboration between the University of the West of England and the University of Bristol include gaming, projections, music, connected objects, location-based media, robotics, digital displays and new forms of performance. And in Brighton, Wired Sussex is bringing together a group of artists and creative technologists to understand the possibilities that 5G mobile data networks will offer for creativity in the coming years.

When I visited the Faculty of Creative and Cultural Industries at the University of Portsmouth, the students and researchers showed me an Aladdin's cave of virtual reality technology, much of which could change the relationship with how we interact with arts and culture in the coming years. They've already begun thinking about the creative possibilities this new high-end technology could introduce into our lives once prices fall and it becomes part of the mainstream.

❝ *When technology and the arts come together, there always seems to be a real spark of extra creativity.* ❞

However, my favourite use of new technology in a cultural setting came not in this country, but while I was on holiday in New York. I visited the Cooper Hewitt Design Museum, which is not far from those other great NYC cultural icons, the Guggenheim and the Metropolitan Museum of Art. The curators at Cooper Hewitt have made technology the central selling point of a visit to their relatively recently renovated museum. When you buy your ticket, you are handed a digital pen, which enables you to interact with virtually everything on show. You can use it to draw on large touchscreen tables and to zoom in on pictures to find out more about objects from the collection that aren't on show in current exhibitions (everything has been digitised). Now, this is the bit that really excited me – you can 'collect' and 'save' objects around the gallery by simply pressing the pen onto any of the museum labels. All the details – as well as any art you create yourself while you are there – are saved to a dedicated web address, which is printed on your ticket. When you get home, you can log on to the website, and everything you have collected during your visit is there for you to keep. It's absolutely brilliant. I would love to see it in every museum the world over.

It's the sort of innovation that is loved by Ian Livingstone, the co-founder of the retailer Games Workshop and former chairman of the British software technology developer and video-game publisher Eidos. He believes that the bond between technology companies, artists and arts organisations is part of a continuous chain of creativity:

'We are only as good as our last creative idea. If we want to be a country of innovators we need to be constantly creative. To become creative, innovative and imaginative, we need to expose ourselves to new ideas. A vibrant arts and culture community is the easiest way to make this happen. The games industry has benefited enormously from increasingly sophisticated classical music soundtracks played brilliantly by orchestras like the Philharmonia. Many games developers now pay large sums to classical composers to write scores for their games, exposing a new generation of young people to classical music while enhancing the creative experience of playing these games. We have to stop thinking about arts and culture as simply nice to have. They are just as important as well-maintained roads and bridges. By giving us the chance to stimulate our minds with new ideas and experiences, they give us the opportunity to become more creative. Arts and culture are the infrastructure of the mind.' [5]

The Philharmonia Orchestra's meshing of classical music and new technology doesn't stop with the recording of symphonic video-game soundtracks. I caught up with their Universe of Sound project in a huge marquee pitched right outside the main shops in the centre of Truro. This free interactive digital installation, which has toured all over the country, allows anyone to explore an orchestra from the inside. The Philharmonia's players, under the baton of Principal Conductor Esa-Pekka Salonen, perform Holst's *The Planets*

[5] 'How Public Investment in Arts Contributes to Growth in the Creative Industries', Creative Industries Federation (2015)

on screens all around you. As you walk through the different sections of the orchestra, you hear and see the piece of music from the point of view of a player in that section. The project uses planetarium-style projections, massive video screens, touch screens and movement-based interaction so that you can change what happens to the music and the orchestra in front of your eyes and ears. It's an illuminating introduction to how an orchestra works and, on the afternoon I was there, the marquee was packed full of people of all ages, all immersed in classical music.

The Royal Opera House is another cultural organisation that has embraced the use of new technology to take its art to audiences beyond those it can fit inside its Covent Garden home. Through a network of big screens, people around the country have been able to watch the highest-quality opera free of charge in city centres. Meanwhile, the introduction of screenings in theatres, halls and cinemas up and down the land has taken the art form to even more people. Other major arts organisations do the same, with the National Theatre's NT Live streaming to venues all over England, from the Stephen Joseph Theatre in Scarborough to the Courtyard Theatre in Hereford, and from the Brewery Arts Centre in Kendal to St George's Theatre in Great Yarmouth. Nearly 9 million people have watched NT Live broadcasts since their

" The bond between technology companies, artists and arts organisations is part of a continuous chain of creativity. "

inception in 2009. Research commissioned by Arts Council England and the British Film Institute shows that this live event cinema is worth £35 million annually in the UK and Ireland, accounting for more than 3 per cent of total box office sales.[6]

Not only do these screenings increase home-grown audiences for these major national companies, but with cinemas and theatres around the world participating, they boost the international 'brand recognition' of producing companies. The number of audiences seeing theatrical shows in this way is impressive. At the end of 2015, one live stream of Benedict Cumberbatch starring in a Sonia Friedman production of *Hamlet* at London's Barbican Centre was watched by more than 225,000 people at cinemas around the globe. At the same time, smaller players such as Cornwall-based Miracle Theatre are using the available technology to stream their productions to a far wider audience than would otherwise see them.

For the Royal Shakespeare Company's executive director Catherine Mallyon, this type of live event cinema offers a huge boost:

'Extending reach through our Live from Stratford-upon-Avon cinema broadcasts and our free Schools' Broadcasts . . . has

[6] TBR Economic Research and Business Intelligence, 'Understanding the Impact of Event Cinema: An Evidence Review', Arts Council England and the British Film Institute (2015)

been game-changing in terms of our offer to young people and
teachers and for our international reach.'[7]

Traditional broadcasters also offer opportunities for taking publicly invested arts content and disseminating it to much wider audiences than would traditionally be achieved in a museum, gallery, opera house, concert hall or a theatre. Sky Arts, Channel Four, Channel Five and ITV all have a role to play, as do digital content aggregators such as YouTube, Amazon and Google. Record companies like Universal Music and entertainment businesses such as Global (which owns the UK's biggest commercial radio brands including Capital, Heart, Classic FM, Smooth and LBC) now see themselves very much as audio-visual content providers and are increasingly important players nationally and internationally. But I believe that right now it is still the BBC that offers the greatest opportunity in this regard.

The BBC is publicly funded and has an obligation to provide a service to the public. Whether it is the broadcasting of existing cultural events, the creation of television-specific artistic events, documentaries and magazine programmes profiling arts and culture, local radio coverage of creativity happening on people's doorsteps in villages, towns and cities across the country, or more general television and radio programming that blurs the line between entertainment and art, the BBC has a responsibility – and is best placed – to lead the way.

[7] Digital R&D Fund for the Arts, 'Digital Culture 2015: How Arts and Cultural Organisations in England Use Technology', Nesta, Arts & Humanities Research Council, Arts Council England (2015)

The director general of the BBC from 2013 to 2020, Tony Hall, was formerly chief executive of the Royal Opera House, so it's not surprising that arts programming featured large during his time in the BBC's top job. His arrival saw a marked increase in the prominence of the arts on BBC television and radio and on the iPlayer and it seems clear that he regarded this area as a personal legacy:

> *'We're the biggest arts broadcaster anywhere in the world – but our ambition is to be even better. I want BBC Arts – and BBC Music – to sit proudly alongside BBC News. The arts are for everyone – and, from now on, BBC Arts will be at the very heart of what we do. We'll be joining up arts on the BBC like never before – across television, radio and digital. And, we'll be working more closely with our country's great artists, performers and cultural institutions.'* [8]

We live in a fast-moving world and arts and culture organisations can't afford to stand still. They need to be as creative in embracing technological advances as they are in what they might previously have regarded as the 'core' part of their business. Any creative organisation that doesn't make use of new technology to create work, distribute their output and run their business risks becoming irrelevant not just to the next generation of audiences, but to the mainstream audiences of today.

[8] http://www.bbc.co.uk/mediacentre/latestnews/2014/bbc-arts-release.html

Technology should not be seen as an add-on to what they do, but a central pillar of their creative strategy – and one of the ways in which they can ensure their art reaches the widest possible audience. We all talk a good deal about reaching younger audiences, but without a coherent strategy for distributing content on handheld digital devices, there is a risk that arts content could fail to connect with whole swathes of the younger generation, because this is how young people consume most of their entertainment. Given the abundance of creativity within the arts and culture sector, we should be at the vanguard of development in this area.

Worldwide entertainment content commissioners such as Netflix and Amazon rely on top-quality, real-time data to help them make editorial and marketing decisions. Our cultural organisations also need to use all of the data available to them to maximise business opportunities – and to enrich the knowledge base which feeds their creative ideas. This includes sharing data between organisations. Failure to do this means that producers, programmers, marketers and venues are operating without the insights that might enable them to transform their businesses.

For those arts and culture organisations who are prioritising it, investment in technology is paying dividends by enabling them to take the best creative work to more diverse audiences in more efficient and effective ways. These are the clear benefits of the Innovation Dividend. But more than with any other area of investment, there is a risk that by investing too little too slowly, this dividend could quickly slip away. And because

technology allows all arts and cultural organisations, wherever they happen to be based around the globe, to compete as equals, the competitive challenges are as likely to come from the other side of the world as they are from just down the street. As the former US President Barack Obama noted in his very first State of the Union address:

> 'The first step in winning the future is encouraging American innovators. None of us can predict with certainty what the next big industry will be or where the new jobs will come from. Thirty years ago, we couldn't know that something called the internet would lead to an economic revolution. What we can do – what America does better than anyone else – is spark the creativity and imagination of our people.' [9]

The UK's creative industries are good at innovation, but our international competitors are good too, so we can't afford to rest on our laurels. The challenge is coming from countries such as China, India and South Korea, all of which are proving to be great innovators when it comes to the creative industries. We must continue to invest so that innovation can thrive in the UK. Only then can we be sure that the Innovation Dividend will continue to be realised.

[9] https://www.whitehouse.gov/the-press-office/2011/01/25/remarks-president -state-union-address

the place-shaping dividend

in brief. . .

Artists, arts organisations, museums and libraries have the power to regenerate, define and animate villages, towns and cities, including those places where there has historically been little arts infrastructure or activity. Some of this country's most notable regeneration programmes have culture at their heart. Investment in arts and culture should be made in all parts of the country, enabling centres of artistic excellence and creativity to thrive throughout England. The role of local authority investment in arts and culture remains of paramount importance. Increasingly, universities are major investors in arts and culture in their local areas, sometimes directly running arts organisations. They are a positive force for good in their local cultural ecology.

The climate crisis

Before I delve into the detail of the places where we live, it would be wrong of me to fail to place the narrative of villages, towns and cities across England into the context of what's happening right now on a far bigger scale to our planet in its entirety.

The climate crisis and environmental degradation are undoubtedly two of the most urgent and challenging issues of our time. And I believe that artists, arts organisations, museums and libraries all have an important role to play in responding to them. Collectively, we are in a strong position to be able to curate a conversation around climate change and to translate words into meaningful actions that help to reduce the threat we all face.

Back in 2012, the Arts Council made the decision to embed environmental sustainability into the funding agreements for National Portfolio Organisations. This deceptively simple policy has had a huge impact. Working with Julie's Bicycle, a London-based charity that supports the creative community to act on climate change and environmental sustainability, we've built an important dataset on the environmental impact of England's cultural organisations. And we've supported arts organisations, museums and libraries in building their confidence and knowledge around carbon, leading to an impressive reduction in emissions and energy use over the years.

What I've found most inspiring is the way that organisations and artists have embedded climate action into the heart

of everything they do, demonstrating imagination, leadership and ambition; collaborating across the sector, as well as with commercial and civic partners, to drive greater change; and using their platforms to engage audiences with these issues.

While I'm proud of all the progress that has been made so far, there is much more that needs to be done. Innovation and creative thinking have never been more vital. The scientific community has issued a clear warning that the coming years are critical to avoiding irreversible global warming, which will have devastating consequences.

'Environmental Responsibility' is a key pillar of *Let's Create*, the Arts Council's strategy for 2020 to 2030. It's one of the four 'Investment Principles' that those we work with will have to respond to. Through this, we set out an expectation that organisations will act as leaders in their communities, taking an environmentally responsible approach to running their businesses, and promoting the need for environmental responsibility through their partnerships and with their audiences.

❝ *The climate crisis and environmental degradation are undoubtedly two of the most urgent and challenging issues of our time ... Innovation and creative thinking have never been more vital.* **❞**

The economist Richard Layard argues that climate action is 'central to the happiness of future generations' and demands our current attention. Happiness, he notes, 'requires peace and security, and in many areas of the world climate change will imperil both'.[1] We all have a responsibility to act, and to act quickly. If we get this right – and play our part – our actions today will continue repaying positive dividends for generations to come.

Post-industrial growth

The climate crisis requires change on a global scale. It affects us all. In contrast, many of the most exciting artistic and cultural innovations that I've witnessed over the past five years operate locally. Take my first visit to the National Glass Centre in Sunderland, for example. It was a bright spring day. The view towards the mouth of the River Wear and the North Sea beyond was spectacular, with the sunlight sparkling on the dancing waves. I love the rugged beauty in the post-industrial landscapes of our towns and cities, particularly across the Midlands and the north of England. I'm fascinated by the stories that these places have to tell – their buildings offer glimpses of the past, hinting at the reasons they grew as towns and cities, suggesting great wealth and a legacy of civic pride. Many rose on the back of pioneering industry – in Sunderland's case it was ship-building and coal-mining – but faced economic decline as their traditional industries faded.

[1] Layard, Richard, *Can We Be Happier? Evidence and Ethics* (London: Pelican, 2020)

Today there is a sense of resurgence – with art and culture at its heart. That process makes a place like Sunderland exciting. It speaks volumes for the creative possibilities of what can be achieved in towns and cities through investment in art and culture. This delivers our fifth dividend, which centres on place-shaping.

The second of my many visits to the National Glass Centre came amid gale force winds and heavy rain. This time, I didn't hang about outside, admiring the views. The winds were so strong that I saw two women literally blown off their feet.

Whatever the weather, the National Glass Centre is a fantastic combination of a museum and gallery – and a living, breathing hub for creativity and learning. It celebrates Sunderland's long history of glassmaking, which dates back more than 1,300 years. The gallery is at the forefront of glassmaking and ceramics. I've seen stunning contemporary pieces there by such artists as Emma Woffenden, Richard William Wheater and Jeff Zimmer, and of course, such renowned Sunderland-based glass artists as Jim Maskrey and Jeffrey Sarmiento.

Because the building is operated as part of the University of Sunderland, it is also home to 130 students studying glass and ceramics. They range from teenagers starting out on careers and studying at foundation-degree level, through to expert students working for their doctorates. In addition, thousands of schoolchildren take part in education events each year and crowds of adults and children turn up to the

free daily glass-blowing demonstrations. I enjoyed having a go myself – and I have the resulting glass bauble sitting in my office to prove it.

It's strategically important for growing our national productivity that we develop centres of creative excellence across the country, just like we have in Sunderland. Artists of all disciplines should be able to live and work in their communities, producing original work that will enrich our national culture, while at the same time changing the face of their locality.

The power of cultural investment to drive growth in our cities was recognised by an independent enquiry chaired by the chief executive of Salesforce in the UK and Ireland, Dame Jayne-Anne Gadhia. The year-long investigation set out to develop a new model to help culture flourish in UK cities. Publishing its findings at the end of 2019, Dame Jayne-Anne's team made a series of recommendations of how UK cities could make greater use of cultural assets to promote thriving communities and to compete successfully for talent, tourism and investment – while developing new income streams that will support culture for the long term. Their report also emphasised the role of culture in attracting people to cities as places in which they want to work, live, and play.

Chief among its recommendations was the creation of Cultural City Compacts to bring together civic leaders and partners from culture, business and education to make best use of resources and secure the social and economic benefits that come from embedding arts and culture in civic life. Northampton, Exeter,

Morecambe Bay and Nottingham are among the first places to launch the Cultural Compacts, with investment from Arts Council England helping to get them started.

Boroughs, towns, cities and capitals of culture

Before dawn on a July morning in 2016, 3,200 people of all shapes and sizes assembled in the ancient port of Hull, stripped naked, painted themselves blue and paraded through the deserted city, sometimes lying down in the street like beached whales, sometimes posing in lines like frozen waves, and sometimes filling the city's squares like an incoming flood. A man stood on a stepladder shouting at them and taking photographs. They were clearly having a good – if chilly – time; but there was a prevailing air of serious intent, and the whole thing had some kind of underlying plan.

What on earth were they doing? And what is the relationship between this weird woad-coloured event and our hopes for a better and brighter future?

It was of course a work of art. One of those extravagances that serve no obvious purpose yet can be mesmerising to watch, leaving a lasting mark on participants and setting in train a series of far-reaching consequences.

This work of art was *Sea of Hull*, created by Spencer Tunick for the Ferens Art Gallery in the lead-up to Hull's year as UK City of Culture in 2017. Using people like water, he marked the old hidden waterways of the port, recalling its past. Those

who took part came from all walks of life and most had not had much to do with art of any kind before, never mind taken part in anything quite so extraordinary. Many have since talked about the sense of significance the project gave them. How powerful it felt to overcome their reservations, to share their vulnerability and their humanity and to be collectively part of something. To do something different; something absurd, beautiful, passionate and historic.

In a city that had spent decades not always getting the luckiest breaks, and where people were fed up of being told what to do and what to consume, those cold blue humans had begun to feel the revivifying power of creativity.

Sea of Hull was the curtain-raiser to a hugely beneficial twelve months. To my mind, Hull's year as UK City of Culture was an unmitigated, rip-roaring, awe-inspiring, life-enhancing success. It's a city that I know and love, having lived there for three years as a student in the early 1990s. It's real and gritty, a great port with a proud industrial legacy and a place that prizes self-sufficiency and individual thought – a home to whalers, fishermen, dockers, Quakers, painters, poets and musicians. It's unquestionably seen hard times over the years, but it has never lost its creative soul.

I personally witnessed so many great moments in Hull during 2017: from the opening night that saw Hull's rich history brought to life in beautiful projections onto the city's buildings; to performances by the Royal Shakespeare Company at Hull Truck Theatre and by the Royal Ballet at Hull New

Theatre; to the opening of the Turner Prize exhibition at the Ferens Gallery; to the day I spent in my turquoise and pink uniform with the indefatigably enthusiastic volunteers who provided such a warm welcome to every visitor from the moment they stepped off the train at Hull Paragon Station.

A personal high point was hearing the former UN Secretary General Kofi Annan at Hull City Hall delivering the annual Wilberforce Lecture, established in honour of Hull-born William Wilberforce, who led the eighteenth-century movement to abolish the slave trade. I have seen and heard many public speakers during my time, but I'm not sure I have ever encountered anyone with so great an onstage presence, with the ability simultaneously to exude wisdom and warmth, gravitas and meaning.

Today, there's a new spirit in Hull. And much of this has come about because of the year it spent as UK City of Culture in 2017. Hull has changed for the better and it's a living, breathing case study of why creativity matters. Its year in the spotlight has managed to change perceptions about the city – locally, nationally and internationally. It has boosted the economy, attracting visitors, investment and jobs. It has broken down barriers between the city's communities. And it has had a direct impact on individual citizens – with more than 95 per cent of Hull residents seeing or participating in one of the many events that took place during the year.[2]

2 *Cultural Transformations: The Impacts of Hull UK City of Culture 2017 – Preliminary Outcomes Evaluation* (Hull: University of Hull Culture, Place and Policy Institute, 2018)

The benefit that can be gained from sustained focus on art and culture in a place was clearly seen following Liverpool's year as European Capital of Culture in 2008. In November 2018, I took part in a symposium to mark the tenth anniversary of the designation organised by the Institute of Cultural Capital, a strategic collaboration between the University of Liverpool and Liverpool John Moores University. The institute had been researching the impact of Liverpool's year as European Capital of Culture in the decade since it ended and they identified positive benefits in seven key areas:

- image and reputation

- participation and identity

- cultural vibrancy

- economy and tourism

- governance and leadership

- social capital and wellbeing

- physical environment and heritage[3]

Liverpool and Hull have much in common. Both cities built up their local industries based on their proximity to water. In the 1840s, around 40 per cent of the entire world's trade passed through Liverpool and it became a highly prosperous port. Later, it became the glamorous gateway to the USA with everybody who was anybody arriving or departing

[3] http://iccliverpool.ac.uk

from the city's docks. Historically, Hull's seafaring activities never quite had the same sense of glitz as their cousins on the opposite side of England's coastline. Alongside a thriving port, fishing was the main staple here. Still, Hull can – and should – claim its place at the centre of this country's history, although perhaps in the past it has done this a little more quietly than other places.

Good things don't happen in places by accident. Instead, they come about because of leadership and partnership. Before 2017, Hull City Council's leader Stephen Brady worked with partners from government, from the University of Hull and from industry to bring business to Hull, as well as with national investment organisations such as Arts Council England, the National Lottery Heritage Fund, the National Lottery Community Fund, the British Council and the BBC. Even in difficult times, Hull kept its faith in the arts, so the Arts Council – and other funders – kept faith in Hull. The sense of ambition in the city has built over time, extending the cultural ecology of the place, which in turn has supported more ambition. Hull has seen an upward spiral of growth, with art and culture at its heart.

For me, it's not only about what was achieved in 2017. It also has to be about a legacy of cultural growth. The year of being UK City of Culture enabled Hull's leaders to change the place in physical terms, with significant capital invested in refurbishing the Ferens Gallery and rebuilding Hull New Theatre, as well as major improvements to pavements and lighting in the streets containing the main shops and restaurants,

alongside the brand new 3,500-seat Bonus Arena, which brings big-name concerts and events to the city centre. But, just as importantly, the stimulus of culture showed the people of Hull what more is possible with their city, changing the perceptions they have of their environment. It has already changed the world's perceptions of Hull. Ahead of its year as UK City of Culture, Hull was named as one of the 'Top Ten Cities' in the world to visit, alongside Reykjavik, Nashville and Amsterdam, by the *Rough Guides* travel books:

> *'After being named the least romantic city in the UK in 2015, and once crowned one of the "crap towns" of the UK, things are finally looking up for Hull. . . it's brimming with new hotels and restaurants, and even more of that distinctive home-grown creativity the city has always had. There are atmospheric old-timey pubs, eight excellent museums and a picturesque Old Town with cobbled streets. This year's fun is set to culminate in the September Freedom Festival, when the entire city is turned into a stage for performers and artists.'* [4]

That Hull has gone from being named the worst place to live in the UK in 2003 to being one of the world's essential destinations shows the journey the city has made. It also demonstrates the power that long-term strategic investment in arts and culture has to change a place for the better.

[4] www.mirror.co.uk/news/world-news/rough-guides-reveal-worlds-top-7105613

The UK City of Culture mantle has passed on to Coventry for 2021 and big things are expected as the UK's cultural focus shifts here for twelve months. The artistic director Chenine Bhathena is promising large-scale spectacle, music, dance, theatre and poetry as well as more intimate, celebratory cultural and heritage experiences in every ward of the city.

Right now feels like a moment for the Midlands to shine, with a cultural festival planned also around the Commonwealth Games in Birmingham in 2022. Its creative director Martin Green made his name as the executive producer of the London Olympic and Paralympic Games opening and closing ceremonies in 2012 and as the chief executive of Hull City of Culture 2017. He's also heading up the government-backed UK-wide festival of creativity and innovation in 2022. These major national events have the opportunity to bring the work of our very best artists and arts organisations to new audiences on a huge scale. Not only will this enrich people's lives in communities up and down the country, but it also helps to demonstrate the value of sustained, strategic public investment in arts and culture. Without that investment, we wouldn't have the creative individuals and organisations to call upon to make these big events come to life.

The Mayor of London, Sadiq Khan, has also recognised the power of focusing on culture in a place, launching a new London Borough of Culture award which comes with significant investment and an increased profile for the winning borough. Waltham Forest was named the first London

Borough of Culture in 2019, with Brent taking over in 2020, Lewisham in 2022 and Croydon in 2023.

These titles – whether national or local – are far more than a branding exercise. The winning places in these highly competitive processes need to convince the judges that they have an artistic programme and sustained investment in cultural infrastructure that makes them worthy of the title. In Liverpool's case, the investment in becoming European Capital of Culture proved to be the key to a catalytic change.

The same is true even for the cities that don't end up winning. Leicester put forward a very credible bid to become UK City of Culture 2017, but was beaten by Hull. Nonetheless, the benefits of the thinking that went into that bid have been huge for Leicester, with cultural activities now central to the way in which it defines itself as a place. The City Mayor Sir Peter Soulsby has driven forward Leicester's cultural agenda on the back of the interest sparked by the City of Culture bid. The people who live there have seen a massive place-shaping dividend, not least from the discovery of Richard III's burial place under a car park in the city, which has seen a surge of heritage-related activities across the city, many of them under the stewardship of the University of Leicester. And Leicester is a place with big plans for the future too. At the beginning of 2020, I took part in an inspiring launch event at the city's De Montfort University for an ambitious cultural strategy for Leicester spearheaded by Sir Peter. It sets out plans for a decade of exciting growth centred on the arts, culture, heritage and the creative industries.

It's a phenomenon I've witnessed in other cities and towns around the UK. Leeds was one of the frontrunners bidding to be European Capital of Culture in 2023, but the UK's exit from the European Union meant that British cities were no longer eligible for the title. Such is the commitment to culture by Leeds City Council and its leader Judith Blake that they were undeterred, promising to invest in a programme of creativity culminating in a major series of cultural celebrations across the city throughout 2023. The appointment of highly experienced theatre maker Kully Thiarai as Leeds 2023's artistic director is a statement of ambitious intent and I'm eagerly anticipating the programme that she develops. Every time I am in Leeds I get a real sense of growing excitement about how the city is becoming a more artistic, creative and vibrant place in which to live, work and study.

The opening of Channel Four's headquarters in 2020 will be another injection of creativity in the city. Already, television production companies are opening offices there to be close to the programme commissioners. For me, Leeds has long been a national centre of creative education with Leeds College of Music, the Northern School of Contemporary Dance and Leeds Arts University sitting alongside Leeds University, Leeds Metropolitan University and Leeds Trinity

" *Every time I am in Leeds I get a real sense of growing excitement about how the city is becoming a more artistic, creative and vibrant place in which to live, work and study.* "

University. This explosion of creativity in the city provides new opportunities for the students graduating from these institutions. In the decade ahead, Leeds will not only be training the next generation of creative talent, but it will also increasingly be retaining that talent in the city as creative industries employees or as entrepreneurs starting up their own creative businesses.

There's a similar sense of optimism and excitement about renewed cultural investment in other parts of Yorkshire. Just up the road in Bradford, the council leader Susan Hinchcliffe is spearheading a bid for her city to become UK City of Culture in 2025. During 2019, the Arts Council announced a new £2-million investment in THE LEAP, an innovative culture project being run as part of the landmark 'Born in Bradford' project, which is tracking the health and wellbeing of more than 13,500 children from before birth to adulthood. In the same year, the Arts Council also awarded £1.5 million to a consortium of arts organisations and artists led by Theatre in the Mill and the University of Bradford to pilot a radical new producing hub model for live performances in the city. There's a palpable sense of optimism in Bradford these days and it's exciting to see.

Still in Yorkshire, I spent a wonderful day in Rotherham talking to community and arts leaders who are working closely together to increase the level of participation in the arts in the town because they know just how much it can change the prospects of people who are born and live their lives there. And Kirklees Council is putting music at the centre

of everything it does in Huddersfield, building on the success of the town's internationally renowned contemporary classical music festival, its vibrant pop music scene and the excellent students graduating from courses at the University of Huddersfield. The vice-chancellor there, Professor Bob Cryan, is rightly proud that his university is ranked twenty-fifth in the world for Performing Arts in the 2019 QS World University Subject Rankings.[5] Among the mainstream UK universities, only the universities of Oxford and Cambridge ranked higher.

It's not all happening to the east of the Pennines though. I spent a fantastic summer Saturday in Wigan in 2019 for the launch of the town's new cultural strategy which had been curated by two local artists, AL and AL. With the title *The Fire Within*,[6] it's a brilliant and ambitious statement of artistic and cultural intent and, with a manifesto as good as this, I predict big things for Wigan in the years ahead.

Civic leaders in Manchester have been exploring how cultural investment can define and grow their city for the past quarter of a century. The Arts Council's headquarters is in Lever Street, in Manchester's Northern Quarter, so I am often to be found in the city. This bustling, creative area close to Piccadilly Station is home to artists, tech start-ups, performance venues and great places to eat and drink. It is a little known fact that with almost 200 of our team working from

5 https://www.topuniversities.com/subject-rankings/2019

6 http://www.thefirewithin.org.uk/TheFireWithin-Cultural-Manifesto.pdf

our Manchester office, the Arts Council is one of the biggest creative industries employers in the city centre.

This is a city that takes its culture seriously, as evidenced by the artistic ambition of the Manchester International Festival (MIF). I was in Manchester in July 2019 for MIF's seventh edition (as I had been for the fifth in 2015 and the sixth in 2017). I saw a lot of shows there in 2019, but my favourite by far was the world premiere of *The Tao of Glass* produced by Improbable, Manchester International Festival and Manchester's Royal Exchange Theatre. Written, co-directed and performed by Phelim McDermott, this captivating show celebrates the work of the composer Philip Glass. It's brilliant on any night, but I was especially blessed that on the night I was at the Royal Exchange, Glass himself made an unannounced cameo appearance on stage at the piano. It's this sort of surprise that ensures that the festival doesn't just gain plaudits here at home. It gets Manchester noticed globally too. The *New York Times* described MIF as:

> 'One of the leading worldwide incubators for new, cutting-edge art. Though the festival has an international outlook and reputation, it also showcases Manchester stories and talent.'[7]

For visitors coming to the city during the festival, there is no doubt that it's happening from the moment they get off the train at Piccadilly Station. It is advertised behind the

7 https://www.nytimes.com/2017/06/02/arts/a-summer-of-opera-theater-and-music.html

reception desks of hotels as they check in; there are brochures sitting on the desks of their hotel bedrooms; and virtually every lamppost is hung with banners advertising artistic delights. In Manchester, you feel as though you are in a city that declares the arts are for everyone – and follows through on its words.

The city has committed to long-term investment in culture buildings – the infrastructure that sits behind the glittering events. The Royal Exchange has been home to exciting and innovative theatre for the past four decades and the Bridgewater Hall has been the main concert home for the excellent Hallé Orchestra for the past quarter of a century – but Manchester's ambition is bigger still. In the past five years, the Whitworth Art Gallery reopened after a £15-million rebuild and was named 'Museum of the Year'. Meanwhile, up the road, a brand new theatre, gallery and cinema complex called HOME opened to great acclaim. The scale of civic ambition is plain in Manchester's stunning Central Library, which has to rank among Europe's finest twenty-first-century libraries – even though the building that houses it was actually built in the 1930s. It reopened in 2014 after a four-year renovation project.

❝ *In Manchester, you feel as though you are in a city that declares that the arts are for everyone – and follows through on its words.* ❞

As I write this, at the beginning of 2020, the Manchester skyline is dominated by cranes as new apartments and offices shoot up around the city. The site of the former Granada Television studios will be home to The Factory, a huge new performance space which will provide a year-round base for the Manchester International Festival. With 13,300 square metres of space, this will enable dance, theatre, music, opera, visual arts performances and popular culture events to be created and performed at scale. It's going to be an exciting addition not just to Manchester's creative ecology, but also to the country as a whole. At present, there's nothing else quite like it in the UK.

Of course, the city has a long cultural and creative tradition exemplified by the generations of outstanding creative practitioners who have studied at the renowned Manchester School of Art and at the equally widely respected Manchester Writing School, both of which are parts of Manchester Metropolitan University. With the former Poet Laureate Carol Ann Duffy, a professor at the university, the vice-chancellor Professor Malcolm Press is seizing the opportunity to capitalise on his institution's reputation in these areas with a new purpose-built public poetry library opening in 2020 and a new £35-million School of Digital Arts opening the following year.

The leader of Manchester City Council, Sir Richard Leese, has been unstinting in his commitment to culture since he took on his role in 1996. He doesn't see the investment in cultural infrastructure as being less important than other infrastructure investment:

'This reinvention – regeneration by another name – must look not just at the staples of business, economic, transport, education and community infrastructures, but also at cultural infrastructure. Ensuring a city has a "cultural offer" that makes it a place where people and businesses want to live, work and invest is not just desirable – we believe it is essential.' [8]

A capital question

Arts Council England has two sources of funding for the investment it makes – money from the government known as 'grant in aid' and money generated by sales from National Lottery games. The bulk of the Arts Council's government funding is distributed from the Treasury via the Department of Digital, Culture, Media and Sport, with some specific funds also coming from the Department for Education.

In recent years, the Arts Council has increased its investment of National Lottery revenue outside London up to 75 per cent (from a historic position of 60 per cent). For the period 2018-2022, almost 60 per cent of the Arts Council's financial investment in its National Portfolio[9] was to organisations based outside of London (up from 53 per cent in the previous three-year period). I'm wholly committed to growing London's status as a world capital of the arts. A flourishing

[8] Leese, Richard. 'Budgets and finance are important for renewal. But don't forget culture', *Guardian* (17 May 2015)

[9] Arts Council England's National Portfolio includes 841 arts organisations, museums and libraries across England in receipt of regular core funding for a four-year period from 2018 to 2022.

London, with arts and cultural organisations that serve the whole nation, is essential. There is already a strong two-way flow of talent between London and the rest of the country; but that doesn't mean that this flow couldn't become more equitable and more free.

As Claire McColgan, director of culture in Liverpool, puts it, the country's creativity needs to be driven from more than one place:

> 'London is not a threat, but it's also not everything. There is a vibrant cultural offer from Northern Cities like Liverpool. The country can't survive on just the London cultural offer'. [10]

London's international reputation owes much to its arts and cultural life. That is recognised the world over and we should cherish it. If we're talking galleries, there's Tate Britain, Tate Modern, the National Gallery and the National Portrait Gallery; if it's museums you want, take your pick from the British Museum, the Victoria and Albert Museum, the Science Museum, the Design Museum or the London Transport Museum; and then there's the National Theatre, Sadler's Wells, the Coliseum, the Royal Opera House, the Southbank Centre and the Barbican Centre; other cultural gems include the British Library, the Royal Albert Hall, the Globe and the Roundhouse; not to mention the thriving West End Theatres and the Bridge Theatre, founded by Nicholas Hytner and Nick Starr, the double act that took the National

[10] 'UK Cities Culture Report 2015', BOP Consulting (2015)

Theatre to new heights in the early part of the twenty-first century. Walk along any central London street and it won't be long before an opportunity to engage with arts and culture presents itself.

During his two terms as Mayor of London, Boris Johnson argued that a capital city without investment in culture was unthinkable:

> *'No one would ever want to live in a city without culture. Culture is the fuel that drives the urban metropolis. Artists, literary thinkers, designers and directors feed our souls and our imaginations, offering both a mirror and a chance to escape.'*[11]

Munira Mirza worked as the Deputy Mayor responsible for Education and Culture during Boris Johnson's time at City Hall. She has now joined him in Downing Street as the highly influential Director of the Number 10 Policy Unit. During her time as Deputy Mayor she consistently made the case for investment in culture as a means of defining and growing a place:

> *'Culture has become an engine for London's economic growth. . . People and businesses are attracted, in large part by our cultural landscape. We're a city that thrives on buzz and new ideas, but we also guard our traditions. For many there is a degree of constancy in our culture; London won't let you down. However,*

11 'How Public Investment in Arts Contributes to Growth in the Creative Industries', Creative Industries Federation (2015)

it is not just about economics. Culture is the glue that really binds, especially in cities with fast-growing populations. . . Our cultural life rests on an openness to both ideas and people.' [12]

There is a strong consensus around the significance of investment in culture, with London's current Deputy Mayor for Culture and the Creative Industries Justine Simons – appointed by the Labour Mayor of London Sadiq Khan – also unambiguous in her support for the capital's creative industries:

'London's creative economy is worth £52bn a year; one in every six jobs in London is a creative one, and these jobs are growing four times faster than the average economy. But as well as the impressive figures, culture plays a deeper role. It brings us together, offers young people at risk alternative life paths, improves our mental health. And across our communities, culture can create bridges when often there are none.' [13]

When London-based organisations such as Tate take their expertise, knowledge and cultural collections to other parts of the country, we see the benefits of a two-way flow between the capital and the rest of England. Tate Liverpool and Tate St Ives retain the central tenets of what it is to be a Tate gallery – curatorial excellence, presentational flair and artistic

[12] https://www.standard.co.uk/futurelondon/culturecity/culture-is-the-engine-for-our-economic-growth-says-munira-mirza-a3934301.html

[13] https://www.theartnewspaper.com/comment/london-s-resilience-creativity-and-innovation-will-help-us-to-keep-open-for-the-world

integrity – while the offering in each place is also infused with an authentic local flavour. The internationally recognised and respected values of the 'brand' honed by Sir Nicholas Serota and his team in London have successfully been transferred to completely different parts of the country. Since she took over as the director of Tate in 2017, Maria Balshaw has continued to develop its role as a nationally and internationally focused organisation.

The addition of the Plus Tate network of independent contemporary art galleries around the country means that thirty-five different places can benefit from Tate expertise and association with the Tate brand – though each gallery still operates as a completely separate organisation. It's a fine example of a London-based organisation taking on a national leadership role and improving the cultural lives of art lovers all over England.

Gown defining town

As mentioned at the beginning of this chapter, the National Glass Centre is run by the University of Sunderland. It's one of an increasing number of universities that have extended their local place-shaping roles to include investment in art and culture. In my experience, universities tend to be run by culturally aware individuals, so there is often a genuine understanding of art and culture at the top, with a passion for supporting high-quality cultural activities. Sunderland is no exception, with the vice-chancellor Sir David Bell a strong believer in his university's civic role. It's easy to understand

why vice-chancellors take this view. After all, an exciting cultural environment helps attract students – and the best academic staff. The cultural entrepreneur Paul Callaghan, who runs a string of successful internet and software businesses in the north-east, is a big fan of the catalytic role that universities can play in their communities:

> *'Universities, particularly outside London, have an increasingly important place-shaping role as local authorities' remit and resources shrink. Sunderland, an Industrial Age powerhouse now redefining itself in the twenty-first century, has just such a university recognising not only the intrinsic value of culture but also the economic and social benefits that it brings to this transformation.'*

In my journeys around the country, I have also heard university leaders say that investment in art and culture is one way in which they can enhance the lives of everyone in their communities – including those who are not directly connected to the university. It's also a way to attract locally based students, many of whom might not otherwise have considered that university was for them.

The pattern is being repeated around the country, with the University of Derby taking over the running of Derby Theatre; Teesside University now operating the Middlesbrough Institute of Modern Art; Coventry University playing a major role in the city's Music Education Hub; and the University of the West of England working in close partnership with Bristol's Arnolfini contemporary art gallery.

Universities are becoming increasingly important cultural brokers in cities up and down the land.

It's not a new phenomenon; for a long time, many universities have been investing in their own arts infrastructure, serving both students and the wider public. Over the past five years, I've visited many of them, including Warwick Arts Centre, which sits in the midst of the University of Warwick's campus. The University of Nottingham's campus is home to Lakeside Arts, containing the Djanogly Recital Hall, Theatre and Art Gallery, as well as a museum. Southampton University has the Nuffield Theatre, the Turner Sims concert hall and the John Hansard Gallery. Further north, Lancaster University operates its own Nuffield Theatre, as well as Lancaster International Concert Series and the Peter Scott Gallery. Also in Lancashire, Edge Hill University's campus in Ormskirk includes the Rose Theatre and a separate studio theatre. Meanwhile, Plymouth University's Arts Institute occupies a city centre location, as does the University of Newcastle's Hatton Gallery, with the university campus also providing a home for Northern Stage. Nottingham Trent University's vice-chancellor Professor Edward Peck is taking the idea one step further by developing a campus in the town of Mansfield, some fifteen miles outside his university's home city. This investment is an exciting response to the challenge

" For a long time, many universities have been investing in their own arts infrastructure, serving both students and the wider public. "

of how smaller towns might be regenerated in the future. Nottingham Trent has a strong arts and humanities offering for its students and I'm excited to see how this groundbreaking project will bring new opportunities to people of all ages in Mansfield over the coming years.

Travelling further east, I was at Norwich University of the Arts a few years back for the opening night of its brand new East Gallery. The vice-chancellor, Professor John Last, told me that universities should have a 'social contract' with the places they inhabit – as exemplified by his new gallery:

> *'We're all about establishing a creative academic community in which staff and students can make work and research. We're inevitably part of our extended community, and for Norwich University of the Arts, our role in the city and the east of England helps create a dialogue between the university and external audiences. A key aspect of this for us was the establishment of our new, city centre gallery where contemporary work is shown both to public audiences and our university community. Whilst we get no extra funding for this, we see it as our "social contract" with our region and a vital element of the University's role as a place maker and shaper.'*

Arts in rural areas

Universities don't just play an important role in big cities. The University of Cumbria must rank as having one of the most dispersed campuses in the country with students

studying in Carlisle, Ambleside, Lancaster, Barrow-in-Furness, Workington and London. I've visited the university many times and, aside from Ambleside being quite possibly the most beautiful campus anywhere, I am always struck by the relevance to place of the courses developed by the vice-chancellor Professor Julie Mennell and her team. This part of the world is a place of stunning natural creativity and this sense of connection to the environment runs throughout the courses on offer there. Perhaps more than any other university, it manages to capture the rurality of its environment – but yet, at the same time, it places it very much in a connected twenty-first century context. I like to think of the University of Cumbria as being a naturally creative place to learn and to carry out research.

It's not just the university campuses that are highly dispersed in Cumbria. So is the population. But it's just as important to me that people who live in rural communities should be able to have access to ambitious and high-quality artists, venues, museums and libraries. And that they should be able to see their own personal creativity come to the fore too. That's why it was a real pleasure to speak at the reopening of the Rosehill Theatre in Whitehaven after its major rebuilding project in the summer of 2019. And also to see

" *It's important that people who live in rural communities should be able to have access to ambitious and high-quality artists, venues, museums and libraries.* "

(and hear) for myself the work of Full of Noises, a sound art and new music organisation based in a public park on the Furness Peninsula; and to meet the team behind Art Gene, who are reimagining the relationship between artists and the environment from their studios in the former School for the Advancement of Science, Arts and Technology in the centre of Barrow-in-Furness. In their own way, with their own flair, each of these organisations is a beacon for creativity and artistic ambition and excellence in their community. It's so important that we continue to foster the conditions that enable these types of organisations to flourish. They make a massive impact in relatively small places right around the country.

I was in Cumbria just a week before the devastating floods at the end of 2015. Already the ground was sodden and it was raining heavily when I was there, but nobody had any idea how treacherous conditions were to become. The disaster of the flooding was all the worse because many towns and villages had only just got back on their feet after facing 'once-in-a-lifetime' water levels six years before.

One place that suffered badly in 2009 – and again in 2015 – was Cockermouth. This small picturesque market town in the west of Cumbria is home to fewer than 9,000 people and is notable as the birthplace of the poet William Wordsworth. It's a deeply rural town, a long way from the big city lights of Newcastle, Manchester or London. But the people who live there deserve the dividends of great art and culture as much as city dwellers.

There are challenges in delivering arts to rural communities, often centred around economies of scale, accessibility and a lack of physical infrastructure. Moreover, while delivering art in rural areas may mean bringing in a touring product, it is also about understanding and developing the culture that is already local to those places. Big towns and cities don't have the monopoly on creativity.

Cockermouth is lucky to have the Kirkgate Centre, a hive of cultural activity at the top end of the town. Based in a former Victorian school, the Kirkgate Centre not only boasts a 160-seat theatre; it also hosts Arts Out West, West Cumbria's rural touring arts programme, which helps local people to stage arts events in village halls. With just a handful of paid staff, the centre's secret resource is its group of well over a hundred passionately committed volunteers. Between them, they handle everything from selling tickets to sorting out the engineering for the stage shows.

For a 160-seat theatre, the ambition is remarkable, with a rich programme of live shows, family events, special happenings for older people, film showings and a series of community activities that make use of the former school's two floors. The tiny bar and even tinier ticket booth make it an attractive

❝ *While delivering art in rural areas may mean bringing in a touring product, it is also about understanding and developing the culture that is already local to these places.* ❞

little theatre and the love that local people have for the building and what it puts on is palpable. You sense it, as soon as you walk through the door.

Making the finances stack up in places like this will always be a challenge – and that's where public investment in the arts can really count, more so than it does in bigger places. This part of Cumbria isn't packed full of high net-worth individuals – many who live in rural communities like this have incomes much lower than the national average. Often they rely on seasonal work such as the tourist trade. The repeated challenges posed by the flooding can only serve to make the job of the Kirkgate team even more difficult – and the results they have achieved even more remarkable. In a place like rural West Cumbria the role public investment plays in the arts ecology is central to ensuring that there is a meaningful high-quality cultural offer. Without it, Cockermouth wouldn't have an arts hub such as the Kirkgate Centre, which would be tragic for the local community. On this small, communal scale, the correlation between public investment in art and culture and the social dividends are seen and felt all the more keenly.

There are towns and cultural venues like this across the country. In the south-west alone, I could cite as examples that I have visited: Prema in Dursley, Bridport Arts Centre, the Pound Arts Centre in Corsham, the Devon Guild of Craftsmen in Bovey Tracey, The Spring Arts Centre in Havant, Cinderford Artspace, The Engine Room in Bridgwater, and Contains Art in Watchet – each of these organisations does a massive job for communities that live in small places.

Changing people and places

So what about places in the country where engagement in publicly funded arts and culture is not so good? Why is that? Perhaps there's a lack of arts infrastructure or there are higher than average levels of people who find themselves in tough financial circumstances. The Arts Council has set about addressing this through its Creative People and Places programme, which focuses on parts of the country where involvement in the arts is significantly below the national average. The aim is to increase the likelihood of people participating in arts and culture – either by creating their own artistic and cultural activities or by attending cultural performances, venues or events.

Rather than a top-down approach, with a centralised view of the art that people in these areas ought to be engaging in, much of the curating of art involved in these projects comes from the people who live in these places. It's something that the University of Warwick's Warwick Commission on the Future of Cultural Value noted as being important:

> *'We should be encouraging communities to see themselves as co-commissioners of their cultural and arts experiences, working with cultural partners locally and nationally. The challenge for the arts, culture and heritage sectors is to bring people from communities together in ways that reflect their expressions of identity and creative aspiration in a manner that can have a lasting impact on that local society.'* [14]

[14] Warwick Commission on the Future of Cultural Value, 'Enriching Britain: Culture, Creativity and Growth', University of Warwick (2015)

Part of the success of the Creative People and Places pro-grammes is that they are united by common aims, but each of the thirty projects is delivered in a way unique to the place in which it is located. It means that the connection between the place, the organisations delivering the project and local people is richer and more meaningful. So, when I visited *Creative Scene* in West Yorkshire, I saw for myself the way in which they create work by, with and for people in Batley, Birkenshaw, Birstall, Cleckheaton, Dewsbury, Gomersal and Liversedge in West Yorkshire, while the team at *Appetite* showed me how they do the same in Stoke-on-Trent and Newcastle-under-Lyme. And I witnessed how *Left Coast* is a force for creative good and artistic innova-tion in Blackpool and Wyre and *Heart of Glass* is making a real difference to people's lives in St Helens. The same can be said for *Right Up Our Street* in Doncaster, *First Art* in Ashfield, Bolsover, Mansfield and North East Derbyshire, *Transported* in Boston and South Holland, and *Creative Black Country* working in Dudley, Sandwell, Wolverhampton and Walsall.

At the end of 2019, the Arts Council announced a new set of investments in a series of new projects in places as far apart as Bradford, Rotherham, Great Yarmouth, Barrow-in-Furness, Basildon, and Middlesbrough, Redcar and Cleveland. I'm really excited to see what high-quality creative programming and talent will be discovered in these towns and cities over the coming years. The Creative People and Places programme will continue to grow as it is rolled out to more places across England, helping to create better lives as it goes.

One of the most enduring memories of my first few years at the Arts Council dates back to a trip I made to see the work of Bait, the Creative People and Places project in southeast Northumberland. Bait is based in the small towns and villages of Ashington, Bedlington, Blyth, Cramlington, Choppington, Cresswell, Ellington, Guide Post, Linton, Lynemouth, Newbiggin, Seaton Valley and Stakeford. These are places that many people across England might struggle to place on a map, located in an area that has faced huge economic challenges since the closure of the coal mines. Engagement in arts and culture has traditionally been low – not least because there has been precious little cultural activity for people to engage with, even had they wanted to. Bait's work is inspired by the Ashington Group, largely made up of coal miners, with no formal artistic training, who painted in the 1930s and 1940s. They became particularly well known thanks to the play *The Pitmen Painters* by Lee Hall – the man who also wrote *Billy Elliot*. *The Pitmen Painters* premiered at Live Theatre in Newcastle before transferring to the National Theatre in London, going on a UK-wide tour and opening on Broadway.

The Ashington Group's collection of eighty paintings has a permanent home at Woodhorn Museum, a former mine near Ashington, now run by Museums Northumberland. It's a lovely museum and well worth the trip to see the paintings, which offer an authentic glimpse of life in the area between the two world wars. While I was there, I enquired how Bait had got its name. In Northumberland, 'bait' is a snack or lunch, and the name reflects people taking time to make and

share something together. The Ashington Group capture 'bait time' in a number of their paintings.

Some conversations stay with you long after you have them. This was the case for me when I visited the Escape Family Support Centre in Ashington, which offers support to substance abusers and their families in Northumberland. Over tea and cake, I chatted for an hour or so with a group of women there who had been working with Maureen Hanley, an artist provided by Bait, to create their own works of art to hang on the centre's walls. Many of them had never considered that art could possibly be part of their lives: 'We thought it wasn't for people like us,' they told me. But after weeks of building up their confidence and skills, many discovered talents deep inside themselves that they simply didn't know that they possessed. For some, in their sixties, it was the first time they had done anything remotely artistic since they were at school half a century before.

The pride that these women felt in their work shone through as they led me down the corridors, pointing to their paintings, and explaining to me the stories behind each of their works. Not all of these stories were happy – but they were told with such eloquence and passion that they have remained with me since. I asked these new artists what effect this burst of creativity had had on them. To a woman, they said it had given them a renewed sense of pride and purpose in their lives.

Art can do that for people in powerful ways that can be hard to quantify. But I came away from Ashington certain that the

investment in arts and culture in this area was paying real dividends to real people's lives.

'Things like this just didn't used to happen round here' is a refrain that I have heard time and time again as I've travelled around the country as people tell me about the immense change for the better that artistic and cultural activities can have on a place and the individuals who live there.

On one particular occasion, the words were uttered by a Staffordshire woman in her mid-sixties. We were sitting drinking tea in the recently refurbished café at the New Victoria Theatre in Newcastle-under-Lyme. My tea break companions were a group of people from Stoke-on-Trent and the surrounding area, many of whom were engaging with the arts for the very first time because of the work of Appetite, the Arts Council Creative People and Places project based at the New Vic.

Given the level of enthusiasm for Appetite's work that I encountered that day, it is clearly achieving its aim of sparking a latent enthusiasm for the arts among diverse groups of people around Stoke-on-Trent. The leader of the city council, Abi Brown, is a big fan of Appetite's work:

> 'Appetite has created a strong cultural network across the city and has reconnected people with spaces in the city, while creating new opportunities by reimagining things in a different way. Events like "Enchanted Chandelier", "Bianco", and "Big Feast" have changed the perception of Stoke-on-Trent as a great place to live.'

The story was the same when I went to Blackpool. Behind the bright lights and seaside fun, there are some tough stories of genuine financial hardship and deprivation. Another of the Arts Council's Creative People and Places programmes, this time called Left Coast, is beginning to make changes to the place including opening a new artist-run bed and breakfast beside the sea.

The twenty-first-century library

While I was in Blackpool, I visited the town's library and it very quickly gained a place in my heart. I love libraries and the role that they can have in changing people's lives. It might be because I write books, but it's also because libraries seem to me to have a sense of 'possibility' and 'discovery' about them. When you walk inside their doors, you never quite know what you might learn. They are places of transformation, both individually and communally. Libraries are institutions that have built up trust. They have authenticity about them. And in a world where public space is rapidly being eroded, they represent a safe and egalitarian refuge and resource.

There is a huge public confidence in libraries, based on that legacy of trust, which means that these buildings can – and

❝ *Libraries have a sense of 'possibility' and 'discovery' about them. They are places of transformation, both individually and communally.* **❞**

should – be at the heart of our communal life. It's important that libraries continue to be reinvented for the digital future. Libraries have long been ahead of the game in gathering data through library membership, adjusting to the needs of their public, and showing their value through that first point of contact. Think how many lives have been shaped by the advice of a librarian to try this book or that one. The recent roll-out of Wi-Fi throughout England's library network recognised the important role in social connectivity that these buildings play.

But I believe that this connectivity is only part of the bigger communal role, in which the physical space of libraries remains crucial – just as the physical nature of a book is unique. The digital era is here, with all its possibilities for virtual engagement. But it isn't a substitute – it's an addition.

The entrepreneur and philanthropist William Sieghart wrote an independent government report on libraries in 2014. He said:

> *'Libraries are . . . a golden thread throughout our lives. Despite the growth in digital technologies, there is still a clear need and demand within communities for modern, safe, non-judgemental, flexible spaces, where citizens of all ages can mine the knowledge of the world for free, supported by the help and knowledge of the library workforce.'* [15]

[15] Sieghart, William, 'Independent Library Report for England', Department for Culture, Media and Sport, and Department for Communities and Local Government (2014)

The chief executive of the British Library, Roly Keating, has made the point that while his organisation has been at the forefront of digital evolution, libraries have a special something that may outlast the internet. He has pointed out the time frame in which libraries exist – the digital world is barely a teenager while the library has been around for thousands of years. And what libraries represent, with that special legacy of trust and authenticity, is strong enough to accommodate change and still endure.

Libraries are democratic spaces where knowledge is there to be explored. You can either choose where to go to find something specific, or you can let serendipity lead the way. Libraries allow for social mobility; they are places of possibility, opening doors in later life for many people for whom school didn't work. The librarian is there to make sense of the information overload, to be a font of wisdom, advice and guidance. This was neatly summed up by the author Neil Gaiman when he said:

'Google can bring you back 100,000 answers. A librarian can bring you back the right one.'

" *Libraries allow for social mobility; they are places of possibility, opening doors in later life for many people for whom school didn't work.* "

Originally, Blackpool's library was endowed by the Scottish-American businessman Andrew Carnegie. His philanthropic giving resulted in more than 2,500 libraries being built around the world, with some 660 in the UK. Blackpool's Central Library must be one of the most attractive in the country. And Blackpool Borough Council has continued to invest in the building. Inside, it's bright, colourful and welcoming. On the day I was in town, it was full of people reading books and newspapers, using the free computer terminals, or in the friendly café grabbing a break from the hubbub of the busy streets outside.

When I walked in, I noticed that individual words were etched on the windows around the central ground-floor area. It turned out that each word was chosen by the people of Blackpool to define what the library meant to them:

Belong

Illuminate

Aspire

Freedom

Reflect

Stories

Imagine

Curiosity

I believe that they're a wonderful set of words that show how a cultural building can play such an important part in a place – and in the lives of its people. Each of these words is in itself a dividend that comes about directly from a library's place-shaping role.

I've visited some terrific libraries over the past few years, including the recently refurbished central libraries in Manchester and Liverpool, both of which are shining beacons of excellence. The Word, the newly built library in the centre of South Shields, is a terrifically inspiring home for literature and literacy in South Tyneside with a brilliantly curated permanent exhibition celebrating the lost dialects of the north-east, which I heartily recommend. It was here that I learned that a 'fuggie crack' is a smack on the back of the head after a haircut at the barber's; a 'bullock walloper' is a man who drives cows to market; and to 'soogie' is to enjoy a long, hot bubble bath. Altogether, they've collected 2,400 forgotten words and phrase, some of which might give you the 'orly gorlies' (the giggles) as you take a 'tappy lappy' (slow walk) around the exhibition which has been cleverly curated by artists Robert Good and Jane Glennie.

In Barnsley, a stunning new library has been built at the Lightbox as part of a major redevelopment in the centre of the town. Storyhouse in Chester is another building that I originally had to don my hard hat and high-visibility jacket to tour around while it was still a building site. Today, it is a vibrant cultural hub at the heart of its city, combining a library with a theatre, cinema and restaurant. Such is its

importance as a busy community space that the local news-paper's team of reporters now base themselves in the bustling café. These days, the news comes to them, just as much as they go to it.

The Hive in Worcester, which is a partnership between Worcestershire County Council and the University of Worcester, offers a blueprint of how a local library and an academic library can come together to make a truly inspiring place, as does the Forum in Southend, which is a partnership between Southend-on-Sea Borough Council, the University of Essex and South Essex College. If there was an award for the most attractive of the new generation of libraries, then the one at the Piece Hall in Halifax would surely be in the running. It opened in 2017 as part of the refurbishment of this truly awe-inspiring eighteenth-century landmark, which has sensitively been brought back to life thanks to the expertise and investment of Historic England and the National Lottery Heritage Fund.

And the investment in new libraries is not over yet. In Cambridgeshire, the county council is committed to open-ing new libraries as hubs not just for books, but also for other community-based services. I've seen exciting new plans for a brand new library in the centre of Nottingham, and I visited another one in the city on the day that it opened for business in an NHS centre, right next door to the doctors' surgeries. So, although there are challenges to the funding of libraries, these are being imaginatively countered by innovative invest-ment projects happening up and down the country.

Artists change a place

Of course, it's not just the buildings and cultural institutions that can change a place for the better – it's the people too. And, in particular, it's artists. I've seen this time and time again. I noticed it at Islington Mill in Salford. Since the turn of the millennium, a group of artists has lived and worked together in this converted red-brick Victorian mill with its attractive cobbled central courtyard.

Over another delicious home-cooked supper, they told me about their creative space, which centres on collaboration between visual artists making work, galleries where that work is exhibited, recording studios, an events space, and even a bed and breakfast, where artists can stay overnight. Some 15,000 people visit every year and around 100 artists are attached to the building in one way or another. Every inch of the place radiates creativity, with almost every spare surface being used to make, store or exhibit fascinating new pieces of art.

At the other end of the country, I encountered the same buzz at the Resort Studios in Margate. Located in the Pettman Building, a historic Victorian warehouse in Cliftonville, the founders – themselves a group of artists – have created a home for other creative practitioners, including designers, architects, photographers and curators. There's also a printmaking studio, a photographic darkroom and a jewellery workshop.

Resort Studios is just one of a burgeoning number of artist collectives that have made Margate their home. It's no accident

that the town's popularity as a creative hub has increased dramatically since the opening of Turner Contemporary. An imposing art gallery right on the seafront, next to the town's harbour, it came about as a result of a creative vision for the town, which was heavily supported and driven forward by Kent County Council, Thanet District Council, Arts Council England and other public funders and regeneration agencies.

Since it opened in 2011, Turner Contemporary has proved to be a magnet for artists, with galleries and workshops popping up in unloved and disused buildings all around the town. These artists are literally brightening up Margate, with splashes of colour and creativity in unexpected places. Together they're changing the place where they live and work for the benefit of the community as a whole. In just a few short years, their presence is already paying dividends for Margate, lending the place a new sense of optimism and excitement. Not only are they creating great art there, but they're also developing a new narrative for their town, with creativity at its heart.

the enterprise dividend

in brief. . .

Investment in arts and culture pays out economic benefits, including creating jobs and driving commercial success in related industries. Cultural tourism reaps financial rewards for villages, towns and cities. Arts and cultural organisations are developing a spirit of enterprise and entrepreneurialism to enable them to thrive. New financial models have the potential to unlock greater creativity in cultural businesses. Our creative industries are renowned on the international stage and this pre-eminence relies on continued investment to enable the UK to carry on innovating and exploiting its intellectual property to its full potential.

The enterprise ecosystem

The Arts Council Collection has been commissioning and acquiring ambitious and high-quality art for more than seventy years – a lot of which is on tour in galleries up and down the country at any given time. One of my favourite pieces is a drawing by Jeremy Deller called *The History of the World, 1997*. It shows the social, political and musical links between acid house and brass bands, drawn as a flow diagram.

On the face of it, acid house and brass bands may well seem to be two very different worlds, but Deller uncovers a surprisingly large number of geographical, historical and social connections. The same is true with the worlds of public and private investment in art and culture; they are linked in a funding ecology made up of four principal sources of revenue: commercial, philanthropic, local authorities and national public funding.

Commercial revenues are in the main formed of ticket sales, paid-for events, business sponsorship and the retailing of food, drink and other merchandise. Philanthropic revenues rely on smaller charitable donations from groups of patrons or from large payments made by high net-worth individuals. Local authorities will make up the bulk of funding of arts organisations, museums and libraries with other public investment coming from bodies such as the Arts Council, which distributes grant-in-aid funding from the government and also 'good causes' revenue from the sale of National Lottery tickets.

It is worth pausing here to consider just how important the National Lottery has been in the first twenty-five years of

its existence. Every time you buy a National Lottery ticket, a share of the money you spend goes to good causes. Arts Council England distributes money from the National Lottery to arts and culture activities, with UK Sport and Sport England doing the same for elite and grassroots sport, the National Lottery Heritage Fund investing in our national heritage, the National Lottery Community Fund distributing money to community-based charities and the British Film Institute investing in film.[1] In the National Lottery's first twenty-five years, players have raised more than £40 billion for good causes across the UK.

Some cultural organisations have public investment as a significant part of their revenue streams; others operate with it as only a small part of their income; and a third group operate on a completely commercial basis with no public money. Having said that, even this third group tends to be linked to organisations from the first and second group, with a flow of talent, ideas, products and investment running throughout. The Warwick Commission on the Future of Cultural Value noted that none of these funding streams operates in isolation:

> *'It is important to stress the interdependence of the economically successful parts of the creative industries with these publicly supported sub-sectors.'*[2]

[1] Creative Scotland distributes National Lottery Good Cause funds to arts and culture in Scotland, with Arts Council of Wales and Arts Council Northern Ireland doing the same in their respective nations. Similarly, Sport Scotland, Sport Wales and Sport Northern Ireland mirror the work of Sport England.

[2] Warwick Commission on the Future of Cultural Value, 'Enriching Britain: Culture, Creativity and Growth', University of Warwick (2015)

This idea is backed up by research into the relationship between public investment in theatre and the commercial end of the theatre world. It shows that public funding plays an essential part in the whole theatre industry, underpinning a national infrastructure and private sector activity valued at £2.27 billion.[3]

It would be easy to categorise the returns on this investment in purely economic terms. And, indeed, there *are* great economic returns to be enjoyed from sustained investment in arts and culture – and we should never shy away from underlining that fact. The Local Government Association identifies five key ways that arts and culture can boost local economies:

- *Attracting visitors*
- *Creating jobs and developing skills*
- *Attracting and retaining businesses*
- *Revitalising places*
- *Developing talent*[4]

However, to *only* measure this particular set of benefits in economic terms would be to underestimate many of the wider financially related social benefits that the arts and culture can bestow on a place and its people. It's as much a state of mind and a way of operating as it is a set of numbers on a balance

3 Hetherington, Stephen, 'The Interdependence of Public and Private Finance in British Theatre', Arts Council England, Birmingham Hippodrome, Theatre Development Trust (2015)

4 'Driving Growth Through Local Government Investment in the Arts', Local Government Association (2013)

sheet. So, rather than this chapter being entitled 'The Economic Dividend', it's instead called 'The Enterprise Dividend'.

Public investment driving commercial success

Let's begin with some numbers. The UK's creative industries grew by 7.4 per cent in 2018. That's up 7.4 per cent on the previous year, meaning growth in the sector is more than five times larger than growth across the UK economy as a whole, which increased by 1.4 per cent. Our creative industries are now worth £111.7 billion to our country's coffers. That's equivalent to £306 million every day or nearly £13 million every hour. This is a big number. To understand just how big: if you add up everything that the automotive, aerospace, life sciences and oil and gas industries contribute to the UK economy, you still don't get to £111.7 billion. It's easy to forget just how important our creative industries are to our economy. For that reason, we need to make sure that we continue to invest in developing them – and in the talent that will continue to power them forward. And on top of their economic contribution, 2 million people are employed in the creative industries in the UK – that's 6.2 per cent of all employment.[5]

These are impressive figures and it's no wonder that other countries around the globe are sitting up and taking notice of the UK's success in this field, analysing what we have done to spur on this growth. To maintain our position as a world leader

[5] https://www.thecreativeindustries.co.uk/uk-creative-overview/news-and-views/news-new-diversity-charter

we must continue to invest so that we can stimulate further innovation, development and growth – not least by building the education infrastructure that will ensure the emergence of the next generation of creative thinkers and makers who can drive forward our productivity in the coming decades.

It is clear to see the spillover effects of the arts and culture and the creative industries. These are the side-benefits that come as a result of investment in art and culture. Research by Arts Council England and partner organisations from around Europe identified three areas where evidence of these spill-over benefits is particularly strong. These were **knowledge** (stimulating creativity and learning), **industry** (improving business and investment), and **network** (including urban development, health and wellbeing).[6]

Josh Berger, the president and managing director of Warner Bros Entertainment UK and the chair of the British Film Institute, believes that public investment in art and culture pays dividends for the more commercial end of the creative industries:

'As we continue to produce more films, TV series, video games and stage shows here in the UK, Warner Bros hires the very best talent the country has to offer. To support this diverse pool of exceptional talent, and to ensure the UK maintains its position as a global

6 Tom Fleming Creative Consultancy, 'Cultural and Creative Spillovers in Europe: Report on a Preliminary Evidence Review', Arts Council England, Arts Council of Ireland, Creative England, European Centre for Creative Economy, European Cultural Foundation, European Creative Business Network (2015)

leader of creative industries, we welcome and encourage both pub-
lic and private investment in UK artists across the board.'[7]

Job creation is only one of the Enterprise Dividends from investment in art and culture – but a vitally important one for the economic health of a village, town or city. The Local Government Association commented on what it termed the 'pulling power' of art and culture. This is where the financial transaction of a visitor to a cultural institution is amplified by their wider injection of cash into the local area. Our visitors not only spend money on tickets, but also buy products and services from other local businesses – including restaurants, shops and hotels. On top of that, the cultural organisations themselves are direct investors in their local communities, buying services and supplies from local firms, with employees also spending their earnings in the vicinity.[8]

This was clear to see when I visited Theatre by the Lake, beautifully situated near Derwentwater on the edge of Keswick in the Lake District. With forty-five employees, this lovely theatre is actually the biggest employer in the area, so its importance is all the greater, not just because it offers local people and visitors alike the chance to experience high-quality live drama on a main stage and in a studio theatre in a pretty remote part of England, but because it provides a materially important financial boost for the local community.

[7] 'How Public Investment in Arts Contributes to Growth in the Creative Industries', Creative Industries Federation (2015)

[8] 'Driving Growth Through Local Government Investment in the Arts', Local Government Association (2013)

On a much bigger scale, a report into the impact of Liverpool's year as European Capital of Culture in 2008 showed that there were 9.7 million visits to the city because of the arts programme put on that year. The additional economic value of these visits totalled £753.8 million. By the end of 2008, research suggests that 68 per cent of UK businesses believed that being European Capital of Culture had made a positive impact on Liverpool's image.[9] The Mayor of Liverpool, Joe Anderson, describes culture in the city as being the 'rocket fuel for its continued regeneration'.[10] He's working closely with the Metro Mayor for the Liverpool City Region, Steve Rotheram, to continue to grow Merseyside's standing as a cultural destination for travellers from all over the world.

Further along the M62, Greater Manchester Metro Mayor Andy Burnham is adamant about the importance of linking arts and culture to growth:

> *'Culture is central to our society and vital for our residents. The cultural sector is incredibly valuable and not something to be underestimated. We know the economic benefit of culture in attracting visitors and investors to our city region, but also in improving people's health and wellbeing and sense of pride in our wonderful place.'*[11]

[9] Cox, T., Garcia, B. and Melville, R. 'Creating an Impact: Liverpool's Experience as European Capital of Culture', European Capital of Culture Research Programme (2010)

[10] 'Liverpool Cultural Action Plan', Liverpool City Council (2014)

[11] www.thestage.co.uk/news/2018/greater-manchester-mayor-andy-burnham -forms-culture-steering-group-put-areas-arts-map/

The focus is the same in the Tees Valley and in the Sheffield City Region. The former is led by Conservative Metro Mayor, Ben Houchen, and the latter by Labour Metro Mayor, Dan Jarvis. Despite the differences in their politics, they are united in their belief in the power of investment in culture to change their places for the better. The story is the same in the West Midlands. Andy Street, the Conservative Metro Mayor there, says:

> 'Creativity has always been at the heart of the West Midlands' success. It was our creative spark that fired the industrial revolution, igniting a thousand trades where, alongside the furnaces of heavy industry, skilled local artisans fashioned jewellery, coins and trinkets that sold across the globe. In the West Midlands of the twenty-first century, culture and creative are critical, rapidly-growing parts of our economy. They not only define what a place is like to live in, they drive innovation and future jobs, and form a key part of our Local Industrial Strategy.' [12]

Meanwhile, in London, in one of his first speeches after being elected as Mayor, Sadiq Khan underlined the Enterprise Dividend paid back to the capital from its investment in culture:

> 'Supporting the arts and creative industries will be a core priority for my administration – right up there with housing, the environment and security – as one of the big themes that I want

[12] www.conservativehome.com/thecolumnists/2019/06/andy-street-how-cultural-renaissance-in-the-west-midlands-is-driving-economic-growth.html

*to define my time as Mayor. There is no question London with-
out culture would be a much poorer place.'* [13]

The possibilities of cultural tourism are becoming more
widely understood around the country – and the dividends
are not only for the benefit of our biggest cities. Cornwall, for
example, is not only attracting visitors because of its many
beautiful beaches; it has a rich cultural and artistic heritage
that is now being marketed extensively both to visitors and
to permanent residents. Further east along the English coast,
Brighton has built a reputation as an artistic and cultural hub
with much of its economic growth now related to the crea-
tive industries. And the cultural heritage of Lincoln is now
being presented to potential visitors in a coherent way that
links together the city's rich offerings. All of these places use
the high-quality artists, museums, galleries and libraries in
their locality as part of the tourism offer available to visitors.

The impetus for increased cultural tourism can come from
sometimes unexpected sources. *The Great Pottery Throw
Down* television series, which initially ran on BBC Two before
transferring to Channel Four, sees amateur potters compet-
ing against each other in the style of *The Great British Bake
Off* (another runaway hit that began life on the BBC before
being snapped up by Channel Four). It's prompted a surge
of interest in pottery across the country, with many classes
now operating waiting lists. Sales of clay have also increased,

as the viewing public try their hand at making pots at home. It's also done much to bring the traditional craft skills of Staffordshire potters back into the public eye.

Culture, education and tourism consultant Paul Williams, who's the former head of Staffordshire University's business school, says that the television producers' decision to base the series in Stoke-on-Trent has had a beneficial effect on the local area:

> 'That the arts and culture play an important and trans-
> formative role in building destination competitiveness and in
> underpinning the high-yield cultural tourism sector is now
> well established. As well as being a significant contributor to
> Stoke-on-Trent's economy, cultural tourism with a particular
> focus around the city's myriad ceramics attractions and pottery
> making is now reaching out to a much wider audience. This
> recent upsurge in pottery tourism has been partly fuelled by
> the success of The Great Pottery Throw Down, which took the
> medium of crafts and creative clay making into the viewing
> public's front rooms. The subsequent "Throw Down" effect has
> boosted the number of purposeful and serendipitous cultural vis-
> itors to what some might regard as an unconventional tourist
> destination.'

" The possibilities of cultural tourism are becoming more widely understood around the country – and the dividends are not only for the benefit of our biggest cities. "

I witnessed this myself when I was in Stoke-on-Trent to give a speech at the opening of the British Ceramics Biennial, which brought the city's sadly disused Spode factory back to life. This festival showcases the work of the very best ceramic artists from Stoke-on-Trent and around the world. That the British Ceramic Biennial happens here gives it added authenticity and integrity, building on the city's great heritage in ceramics. I sensed a real creative buzz about the place – and although the pottery industry has faced many challenges over the years, Stoke is still a hotbed of ceramic talent, with Emma Bridgewater one of the biggest employers of potters in the area. With strong leadership from Stoke-on-Trent City Council and Staffordshire University, the city's cultural infrastructure is gradually being reinvigorated thanks to groups of enterprising artists, like those I met at the AirSpace Gallery and B Arts. They're growing new cultural businesses in many of the disused industrial buildings in the city, with B Arts even running an artisan bakery as part of the business model that funds its work in the arts.

New ways of investing

Sometimes, the enterprise dividends from investment in art and culture don't come from making investment in traditional ways. We can see spectacular results where public or private money is used to help an arts organisation become more resilient and sustainable, rather than simply to fund its core product.

There are many financial models for investing in art and culture besides simply making grants of public cash. But, to make myself absolutely clear, I am advocating these models as

a means of growing the size of investment in art and culture, not to replace existing public funding. As I stated at the start of this book, I believe passionately that the funding ecology for art and culture in this country needs to have public investment at its heart. The lever of public investment ensures that our arts organisations, museums and libraries are innovative and risk-taking – and that they are reflective of all communities in society, reaching out to everyone everywhere.

That said, it would be wrong to ignore the possibilities of what can be achieved by private money. Philanthropic trusts and foundations such as the Paul Hamlyn Foundation, the Esmée Fairbairn Foundation, the Baring Foundation and the Calouste Gulbenkian Foundation have many decades' experience of careful, considered and insightful investment in arts and culture. And high net-worth individuals have an important role to play: the Duke of Devonshire, who places art and culture at the centre of his Chatsworth estate in Derbyshire; the philanthropists Jonathan and Jane Ruffer, who have put Bishop Auckland on the map as an internationally important centre for Spanish art and regenerated the town beyond all recognition; and the entrepreneur Sir Roger De Haan, whose sustained investment in cultural businesses has transformed Folkestone into a hub for creative professionals. We will always need visionary, far-sighted and generous individuals who have a love of the arts and culture, and pockets deep enough to enable real change.

In fact, we should do far more to encourage and cherish these people, who don't always receive the public praise that their

generous philanthropy merits. While I do not advocate the American model of arts funding, which sees relatively little public investment and a huge reliance on private donors, the development of philanthropic giving to arts and culture organisations should remain a focus for arts organisations in this country, as part of a mixed funding ecology.

Other ways of investing are also starting to bear fruit. The Arts Impact Fund – a partnership between Bank of America Merrill Lynch, the Esmée Fairbairn Foundation, Nesta and Arts Council England, offers repayable loans of between £150,000 and £600,000 to cultural organisations. With up to £7 million to invest, we are seeing some real innovation here because the fund offers an alternative to commercial loans and grant funding. It is the first of its kind in the world to look at the social, artistic and financial return from arts organisations. The first investments from the fund included a £150,000 loan to Titchfield Festival Theatre in Hampshire, to help pay for the construction of a new building, which will enable this volunteer-run theatre company to tap into new revenue opportunities and become more self-sustaining. Rather than a standard grant, this is an investment that will be repaid to the Arts Impact Fund over time, out of that additional revenue. It's also an example of one of the ways

" We will always need visionary, far-sighted and generous individuals who have a love of the arts and culture, and pockets deep enough to enable real change. "

that the Arts Council is investing in the voluntary arts sector, which is an important part of England's overall arts and culture ecology.

New technology means that there will be new ways for everyone to become involved in arts philanthropy – the surface has barely been scratched. For example, think of what might be achieved through online crowdfunding of cultural activities. One way in which this has already been shown to work is for artists to invite the public to fund, say, 50 per cent of a project's value, with the local authority contributing the other 50 per cent once that target amount has been reached. This is yet another reason for arts and culture organisations to gather and share high-quality data on their audiences, because this will lead to more meaningful relationships with audiences and allow such fundraising mechanisms to operate in the most effective way.

There's nothing to suggest that we shouldn't explore other investment models in the future. Perhaps public funders and private enterprises could come together in a far bigger way to offer capital investment that would be repaid, or to act as guarantors to enable greater levels of structured financial risk by creative producers. If cultural enterprises become profitable, maybe they should pay a financial dividend back to their public funder for reinvestment in other nascent artistic enterprises. I'm not in any way advocating turning our backs on the more traditional grant model – but we should keep an open mind about such opportunities. All of these options are worth consideration at different times, and for different organisations.

The Treasury has done its bit to think creatively when it comes to taxation. The introduction of tax credits for orchestras, theatres, opera and dance companies, and museum and gallery exhibitions means that the arts and culture sector – and the public – have benefited to the tune of many millions of pounds. These tax credits are now a well-established and important part of public investment in our creative industries, with other beneficiaries including film, high-end television, animation, video games and children's television.

Announcing the 2016 figures, which saw museums and galleries benefit for the first time, helping 300 exhibitions to be staged across the UK, the Financial Secretary to the Treasury, Jesse Norman, said:

> *'The arts and creative industries make a vital contribution to the UK economy. These tax reliefs have helped support some astonishing and exciting work again this year, celebrating the very best of British culture.'*[14]

The Enterprise Dividend can only be maximised when arts and culture organisations adopt enterprising behaviours. External funders and investors can come up with no end of innovative ways of channelling money into cultural organisations, but it's what these organisations do with the funding when they receive it that makes the key difference. Many artists and leaders of cultural organisations are highly

[14] www.gov.uk/government/news/government-provides-11-billion-cash-boost-to-creative-sectors

❝ *Public funders and private enterprises could come together in a far bigger way to offer capital investment that would be repaid, or to act as guarantors to enable greater levels of structured financial risk by creative producers.* **❞**

enterprising; but others still have a long way to go. The Clore Leadership Programme, which is brilliantly directed by Hilary Carty, aims to tackle this issue by educating emerging leaders from the cultural sector. Those who have been on the course – which is funded by Arts Council England and the Clore Duffield Foundation – now hold a range of influential leadership positions across arts and culture organisations. They are undoubtedly making a difference.

In his wide-ranging 2019 review of England's museums, the entrepreneur, publisher and philanthropist Neil Mendoza was determined in his support for the role of our museums in driving commercially beneficial tourism in towns and cities across the country:

'England has world-class museums of exceptional reputation. Over half the population visited at least one last year. Three of our national museums are in the top ten most visited museums in the world. All of the top ten visitor attractions in the UK are English museums, or places that include museums and galleries as a part of their primary offering.' [15]

15 https://www.gov.uk/government/publications/the-mendoza-review-an
-independent-review-of-museums-in-england

In terms of best practice, there's a lot that publicly funded arts and cultural organisations can learn from the more commercial end of the museums sector. Many members of the Association of Independent Museums operate their core cultural businesses with relatively little public investment, under the association's 'Prospering Museums' framework. Among the many such venues that I've visited myself are: the Black Country Living Museum in Dudley; the SS *Great Britain* in Bristol; and the Compton Verney art gallery in Warwickshire. The framework encourages museums to understand and articulate their purpose; to be financially resilient with strong governance; to steward their collections wisely; to focus on the needs of their visitors; and to be prepared to take innovation and risks. These are all good maxims by which any enterprising cultural organisation should be happy to live.

The Enterprise Dividend is one of the most exciting outcomes of investment in art and culture. When we get it right it enables us to be more creative, to take greater artistic risks and to be truly innovative. Adopting new models from the business world; engaging with new methods of investing; and operating in an entrepreneurial way are all means for enhancing the creative and artistic possibilities for individuals, in organisations or in entire towns or cities. As I have maintained throughout this book, economic outcomes are by no means the only reason for investing in art and culture, but they are one important measure that can unlock new funding streams, allowing our artists and cultural organisations a greater opportunity to prosper creatively.

the reputation dividend

in brief. . .

A boost in reputation comes about as a result of all six of the previous dividends, but it is also a dividend in itself. Many of those towns and cities that enjoy creative and economic success can point to the presence of cultural infrastructure and artistic output as a significant part of their success story. These places have also developed a narrative that shows the importance of art and culture in building their reputations. Often, alliances of arts and cultural organisations are formed to help nurture those reputations. Positive reputations are hard won and easily lost, so continued investment is required if the benefits of this dividend are to be maintained over time.

Telling the story

The first of our seven Arts Dividends centred on creativity. It is the thread that runs through all six of the others. If we think of creativity as being a major input into each of these separate dividends, then our final dividend, which centres around reputation, is very much the 'output' of the process. When added together, all six of our other dividends have a cumulative effect on the reputation of an individual artist, a museum, a library, an arts organisation, a village, town or city – or even an entire art form.

It can take years of insight, consistency, productivity, creativity, vision, knowledge, practice and timing to build up a positive reputation. The old maxim that success breeds success holds true in the art and culture ecology just as much as it does in the worlds of business or sport. Building a credible and authentic narrative is central to successfully reaping the benefits of the Reputation Dividend.

The development of a strong reputation centres around what you do, what you say and what other people say about you. For me, the most powerful reputation builder comes when the third of these is in full swing. When your story is being repeated by people unconnected to your narrative, that's when you know that your reputation is being enhanced.

Right now, by popular consensus, Manchester is one of the cities leading the reputation stakes in the UK as a place where interesting, exciting, innovative things are happening. As

I've described in earlier chapters, sustained investment in the city's cultural infrastructure and in its artistic output has built a compelling narrative that has driven forward its growing reputation as a beacon for arts and culture. This has been combined with strong performances from the Premiership football teams: Manchester City over recent years, and Manchester United over the longer term. And it has benefited from sustained investment and achievement by its great academic institutions: the Royal Northern College of Music, Manchester Metropolitan University, and the University of Manchester, all of which have had visionary leadership from Professor Linda Merrick, Professor Malcolm Press and Professor Dame Nancy Rothwell respectively. It's a potent mix – but the arts and culture element of this success isn't lost on Manchester City Council leader Sir Richard Leese:

> *'The importance of culture and the arts to Manchester's growing reputation cannot be overstated. Cultural regeneration is as much a part of the city's future as the many groundbreaking developments including graphene (famously isolated by researchers Andre Geim and Kostya Novoselov at Manchester University) and the like that are at the same time reshaping and advancing the city's global standing within the knowledge and skills economy.'*[1]

This understanding of the way in which investment in arts and culture drives reputation is by no means limited to

[1] Leese, Richard, 'Budgets and finance are important for renewal. But don't forget culture', *Guardian* (17 May 2015)

Manchester. When I met Karime Hassan, the chief execu
tive and growth director of Exeter City Council, he made very
clear to me the importance to the city of the Royal Albert
Memorial Museum and Art Gallery (known as RAMM and
home to the legendary Gerald the Giraffe). Far from seeing
his local civic museum as a dusty repository for crumbling
artefacts, he told me that it was always his first stop when
giving a tour to representatives of multinational corporations
considering locating in the city. Sustained investment has
resulted in one of the most impressive, well-curated and invit-
ing museums that I have encountered. Many of its collections
are not only of national and international importance, they
also showcase Exeter and south-west England in an exciting
and dynamic way. It's no wonder that the local council uses
it to show off the best of Exeter and to impress visitors. The
local leaders understand that the investment they have made
in this cultural asset pays dividends in terms of their city's
reputation.

Further along the Devon coast, in Plymouth, the city council
has placed investment in culture at the heart of its plans for
expansion. 2020 sees the opening of The Box, a £40-million
capital investment that has transformed the city's museum,

**" *It can take years of insight, consistency,
productivity, creativity, vision, knowledge,
practice and timing to build up a positive
reputation.* "**

rehoused its archives and provided a new contemporary visual arts gallery of national and international significance. Plymouth City Council sees art and culture as central to building the reputation of its city, with the Council leader Tudor Evans describing The Box as a 'game-changer' for arts and culture in the city.

Changing the reputation of a place doesn't happen overnight though. In Plymouth's case, the decision to host the British Art Show there in 2010 was a major landmark on the city's journey towards being a recognised artistic hub. It was a catalyst for a new generation of artists to make the city their home. I met some of them hard at work at Ocean Studios, a wonderful gallery and artists' workspace newly built as part of a redevelopment of Royal William Yard Harbour, a set of Grade 1 former Royal Naval victualling buildings.

Ocean Studios is at the centre of the redevelopment. This is something of a trademark venture for Urban Splash, the property developer behind the scheme. It has specialised in recreating new living and working spaces from old industrial buildings in cities around the country. For Urban Splash's chairman Tom Bloxham, it's not only about getting the mix of cafés, bars, restaurants, offices and residential spaces right. For him, having culture at the heart of a development is what makes it special. He has taken the oath sworn by the citizens of Athens as his company's motto:

> 'We will leave this city not less but greater, better and more beautiful than it was left to us.'

A few years back, Plymouth was named a Social Enterprise City, one of the first in the UK – and the marriage of cultural entrepreneurship with social enterprise has been a feature of the city's transformation. It can be seen through the work of the Real Ideas Organisation, which has knitted together social enterprise with culture and heritage to drive the transformation of the Devonport area – restoring the Devonport Guildhall as a cultural hub and the adjacent column as a civic beacon and visitor attraction. At the time of writing, building work is well under way to restore Devonport's disused Market Hall as a stunning digital innovation hub, the like of which doesn't exist anywhere else in the UK. I've donned my hard hat and high-visibility jacket on a couple of occasions now during the building work and I'm looking forward to seeing it burst into life very soon.

Also in Plymouth, the arts producer and social enterprise company Effervescent, which specialises in work with young people, has forged a partnership with the children's charity Barnardo's and Plymouth University to secure commissions from the council in support of projects that empower children in care. These solutions are considered cost-effective and high-impact in relation to the alternatives. They're also seen as good exemplars of incentivising social enterprise in order to achieve the local authority's corporate outcomes. Plymouth is one of those places in the country where exciting things are happening right now.

In 2015, Battersea Arts Centre in south-west London suffered a devastating fire that resulted in an instantaneous and

heartfelt outpouring of support from all parts of the local community. From the depth of their response, it was clear that for people living in Battersea, this was far more than just a building that put on performances. Over many years, it had built up a reputation for the high quality of its artistic work, and for its extensive engagement with people in the area. A couple of years back, I sat on the judging panel for The Agency, a programme run by Battersea Arts Centre and Manchester's Contact Theatre that helps young people develop their own entrepreneurial ideas through creative workshops. As judges, we were asked to pick three of these projects, which would each be given £2,000 of funding alongside mentoring and support to help make their ideas a reality. It was well worth spending time on a Saturday for; I came away inspired by the creativity of the young entrepreneurs. This was a project that used creative practice in a truly innovative way and brought young people to Battersea Arts Centre who might not otherwise have come.

During his tenure, David Jubb, the organisation's artistic director at the time, made a point of including people who lived in Battersea in everything that went on inside the building. It's something that Battersea's visionary new artistic director Tarek Iskander is continuing to do during his leadership there. At the beginning of 2020, he took things one step further by announcing that Battersea Arts Centre would become the world's first 'relaxed venue', making all of its shows more accessible for disabled people and neurodivergent audiences, artists and staff. On my way home from my day on The Agency judging panel in Battersea, I reflected

that the Arts Centre was a special place. Its sense of inclusive leadership made it unsurprising that the venue was held in such high regard by its local community. It had earned its reputation.

In the north-east of England, the power of investment in culture as a means of building reputation has long been recognised. Back in 2002, the then leader of Gateshead Council, Mick Henry, told the *Guardian* about his vision for using culture to change Gateshead's reputation:

> '*We want to change the image and perception of Gateshead, creating a new city centre along the Quays, while bringing art to the masses and getting over the message that you don't have to go to London to enjoy art and good music. People are becoming proud of Gateshead and they see a future here once again.*'[2]

Turn the clock forward almost two decades and Mick Henry's vision has become a reality. The Baltic contemporary art gallery and the Sage Gateshead concert hall are now cultural fixtures with a national and international reputation, alongside Gateshead Council's investment in public art, which includes *The Angel of the North*, Antony Gormley's magnificent sculpture that towers above Tyneside's main transport links.

Political, cultural and business leaders in the north-east have recognised the power of arts and culture to build the region's

2 Hetherington, Peter, 'Baltic redefines cold Gateshead as hot spot', *Guardian* (12 July 2002)

reputation. This was codified in 'The Case for Culture' published by the North East Cultural Partnership, a group which brings together all twelve local authorities and five universities in the area, with funding from Arts Council England. Cultural entrepreneur John Mowbray, who co-chaired the Partnership during its early years, says it sets out an ambitious plan for growth based on investment in arts and culture in the area:

> *'The Case for Culture builds on a long tradition in the north-east of positively promoting and championing culture and creativity. It will be an important tool in influencing key decision-makers across a range of sectors. We believe it will play a valuable role in establishing the credibility, expertise and significance of the cultural sector to the economic life, health and wellbeing of the whole of the north-east.'*[3]

When arts and culture organisations work closely together, they often achieve better results than if they go it alone. The Liverpool Arts Regeneration Consortium was born in the run-up to the city's time as European Capital of Culture in 2008. It sees seven of Merseyside's major cultural organisations joining together in an alliance that uses culture as a tool for regeneration in the city. Meanwhile, in Coventry and Warwickshire, ten of the area's biggest cultural attractions have come together in CW10, working to build the reputation of arts and culture there. When I met some of its key players at the Compton Verney art gallery in the beautiful Warwickshire countryside, they were keen to point out that

[3] neconnected.co.uk/north-east-takes-case-for-culture-to-westminster/

though a relatively young organisation, they were already achieving more success by working together than they would do if each cultural organisation were operating separately.

Whether it's the Barbican Centre in the heart of the City of London with its concert hall that's home to the London Symphony Orchestra and its music director Sir Simon Rattle, as well as its theatre, art gallery, cinemas and library; the Southbank Centre with the Royal Festival Hall, Queen Elizabeth Hall and Hayward Gallery next to the River Thames; the Royal Shakespeare Company in Stratford-upon-Avon; The Curve theatre in Leicester; Bristol Old Vic; Snape Maltings in Aldeburgh; Tate St Ives in Cornwall; Leeds Playhouse; or the Royal Opera House's production work-shops in Thurrock, investment in art and culture has been at the heart of changing, developing, enhancing and driving forward the reputation of places. Without the inner light of success from arts and culture, the reputations of some of these places might be much diminished.

It's not only at home that reputations are built: the UK is acknowledged around the world for the influence and quality of its creative sector. The Secretary of State for Digital, Culture, Media and Sport, Oliver Dowden, describes the UK cultural sector as 'one of our great calling cards'. For an island our size, we punch well above our weight; UK music exports for example generated £2.7 billion of revenue during 2018[4] and the UK art market was estimated at more than

4 'Music by Numbers 2019', UK Music (2019)

£10 billion in the same year.[5] Fast-growing countries such as South Korea and China are studying our specialist conservatoires and arts universities to understand how the creativity included in our education system has enabled us to become so proficient at producing a generation of world-leading writers, artists, actors, designers, directors, photographers, producers, curators, composers, musicians and software developers.

Audiences all over the world enjoy our creative output. Much of this is developed in this country through Arts Council investment and then toured around the world thanks to partnerships with the British Council and with the Department for International Trade. These global tours can make a significant difference to an arts organisation's bottom line, helping to sustain their work in this country.

The Royal Shakespeare Company, the Royal Ballet, the London Philharmonic Orchestra, the Akram Khan Dance Company, and the Victoria and Albert Museum's *David Bowie Is* exhibition are all examples of organisations that receive public investment for high-quality work in England – and build on that investment to take this work to audiences around the globe, helping to drive up our entire country's reputation as a creative leader.

5 https://www.artbasel.com/news/art-market-report

final word . . .

It is sustained and strategic public investment in artists, arts organisations, museums and libraries that makes virtually everything in this book possible.

This investment makes our villages, towns and cities better, more creative places to be.

It enriches our lives, increases our knowledge and opens our minds to new possibilities, helping us to be happier and healthier.

It gives the UK huge equity on the international stage, building our reputation as an innovative and creative country.

This is the Arts Dividend. It's investment that pays. And we fail to recognise the value of that investment at our peril.

acknowledgements

I am very grateful to all of my colleagues in each of the nine offices across Arts Council England who share their insight, expertise, experience and passion for arts and culture with me on a daily basis. They are a great bunch of people who do more than anyone else in this country to ensure that public investment in artists, arts organisations, museums, libraries and cultural education pays dividends for people right across England.

In particular, I would like to thank those who have read sections of this book, or have assisted me in locating data, making incredibly helpful comments along the way: Abid Hussain, Amy Vaughan, Andrea Lingley, Andrew Mowlah, Anne Appelbaum, Becky Botros, Cate Canniffe, Caterina Serenelli, Claire Mera-Nelson, Clare Titley, Dan Smith, David Ward, Eddie de Souza, Emma Foxall, Francis Runacres, Hannah Clynch, Hannah Fouracre, Hedley Swain, Irene Constantinides, Jane Beardsworth, Jane Dawson, Jane Tarr, John McMahon, Joyce Wilson, Julie Leather, Juliet Brandi, Kate Bellamy, Laura Dyer MBE, Liz Bushell, Mags Patten, Maria Hampton, Michelle Dickson, Nathan Dean, Neil Darlison, Nick McDowell, Nicola Saunders, Nisha Emich, Owen Hopkin, Paul Bristow, Paul Roberts OBE, Peter Heslip, Pete Massey, Pete Modral, Peter Knott, Phil Gibby, Rebecca Blackman, Richard Russell, Ross

Burnett, Ruth Alaile, Sarah Crown, Sarah Maxfield, Sebastian Summers, Simon Mellor, Sue Williamson, Tonya Nelson, Will Cohu and Sir Nicholas Serota CH.

I am, as ever, indebted to Lorne Forsyth, Olivia Bays, Jennie Condell, Sarah Rigby, Pippa Crane, Marianne Thorndahl, Alison Menzies and Jonathan Asbury at Elliott & Thompson for their careful stewardship of this book from concept to print first in 2016 and now in 2020, with their customary care, flair and attention to detail. Particular thanks goes to Pippa for her immense patience, wisdom and good humour every time I pose another seemingly impossible conundrum.

Finally, a big thank you to all of the artists, curators, librarians, teachers and leaders of arts organisations, museums, libraries, music education hubs, schools, colleges, universities and local authorities all over England whom I am privileged to meet every single day. All continue to be very generous in sharing their time and ideas with me. I have seen, heard, experienced and learned so much more than I could possibly fit into this book and I apologise now to the many wonderful people, places and organisations that I haven't been able to include in these pages. You're already playing your part in making the Arts Dividend a reality for so many places in England. I really do believe that by working collaboratively, we can all ensure that many more people right across the country can flourish because of the benefits, opportunities and experiences creativity and culture bring to them. The bottom line is that what we all do every day helps people to be happier. And, to my mind, there can be no greater reward for doing it than that. Together, we're creating better lives.

index